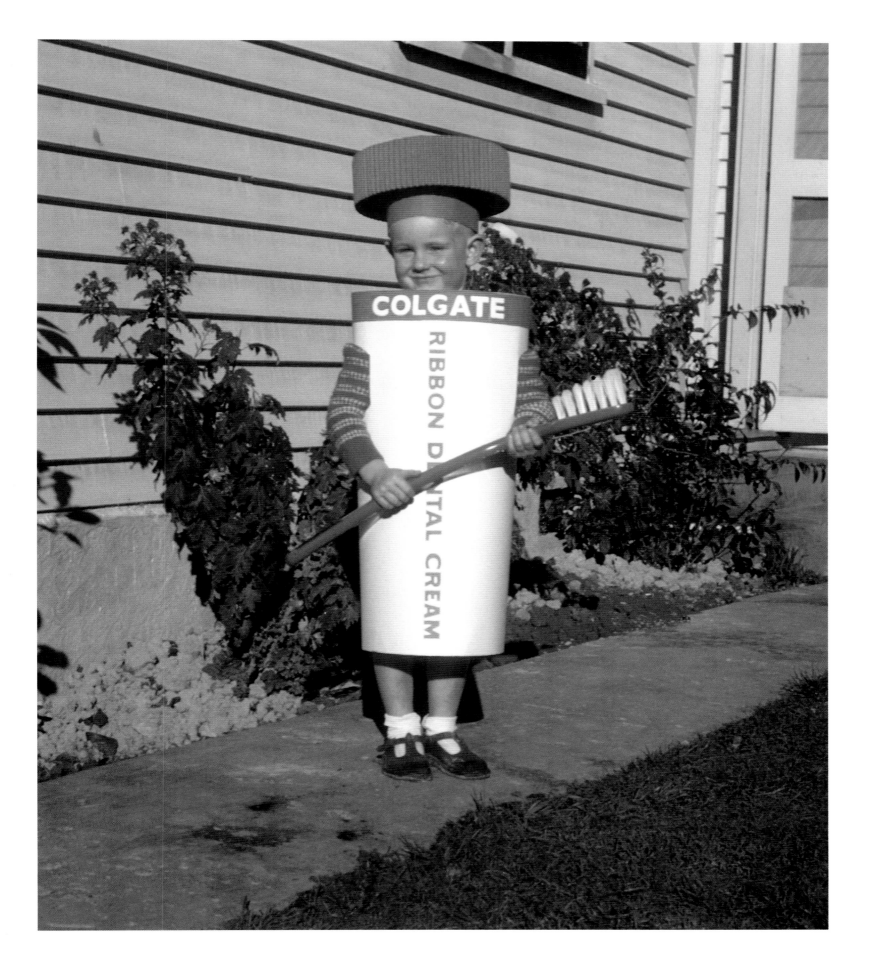

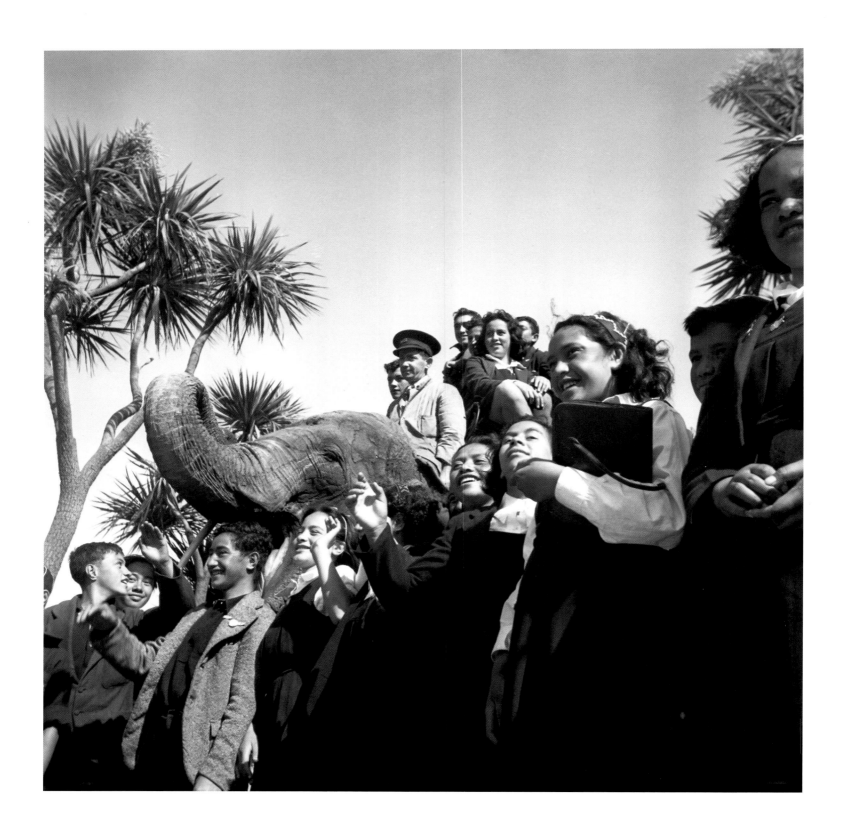

See what I can see

New Zealand photography for the young and curious

Gregory O'Brien

AUCKLAND
UNIVERSITY
PRESS

You are a camera. Your eye is a lens. You open your eyes and images register inside you. Some images remain there a long time. Some might even stay with you for the rest of your life.

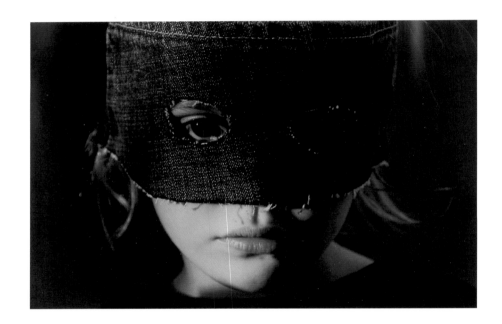

For Helena Hughes (1963–2012)

Contents

A strange box and its contents

A strange box walks the earth. Whatever it sees, it stores away. Sometimes it only sees what it wants to see. It has been known to steal things or take them without asking. The strange box has a shutter and a glass eye. It is a camera. Although, in the world today, it might also be a telephone or a computer or a gadget. A camera can do many things and, especially these days, it can be many things.

All the images in *See What I Can See* were made by New Zealand photographers – or photo-artists, as they are often called these days. Most of the photographs were also taken in New Zealand, so they have a lot to say about this place and about the people, young and old, who live here.

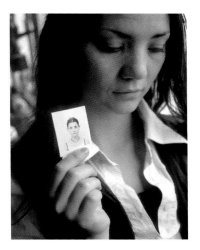

When you look around, you see photographs everywhere: on buildings and bus shelters, in magazines and on Facebook pages. A photograph can be as large as a building or as small as a thumbnail. It can appear on a postage stamp or a billboard; it can drive past on the side of a truck or it can be stuck on a lamp-post.

Photography can be the most practical and useful of things. It can be used to sell houses, cars and beauty products. It can provide a visual account of family holidays and it records how you look for your passport or driver's licence. It describes what it encounters – places, people, objects – very well. Yet it can do other things too.

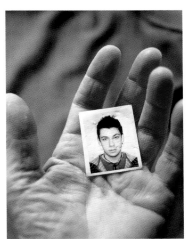

Throughout its history, photography has been a means of creating works of art – just like painting on canvas, making drawings on paper or sculpting in clay. Until recently, many people didn't take photography seriously as a way of making art. The photo-artist Eric Lee-Johnson wrote in 1958: 'Among

- **Mark Smith** (born in Hastings, 1963), *Untitled*, 2014
- **Harvey Benge** (born in Auckland, 1944), *Paula, Paris, November 2002*, and *Mt Roskill Hand, March 2010*

the fine arts, photography occupies a position midway between doodling and washing the dishes . . .' Things have improved over the years. Nowadays, public art galleries collect photographs and most contemporary galleries show new work by photographers. Most of the photographs in this book have been exhibited on gallery walls, and prints are held in collections all over New Zealand and abroad.

A photograph can work magic. At every stage, from the moment a picture is taken until the final print is made, things can happen, intentionally or not. And – as is the case in Megan Jenkinson's photograph below – the world can be given a twist. This book explores the mysterious, alluring capacity the camera has to make things come alive. Two questions crop up all the way through: First, what do these images tell us about the world we live in? And, second, what do these pictures tell us about the art of photography?

• **Megan Jenkinson** (born in Hamilton, 1958), *The Ocean World IV*, 2007

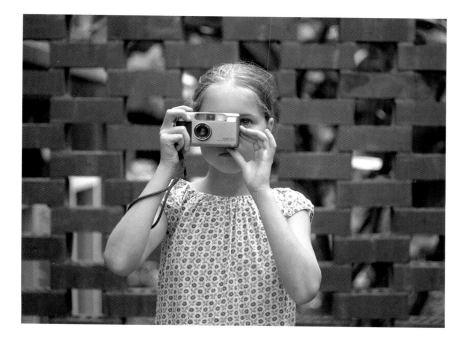

To start, a bit of background. For many centuries artists and scientists have experimented with light and how it can be used to create images. Photography, as we think of it now, began in France early in the nineteenth century with the invention of the camera: a machine which records images by registering light. Most people agree that the first photograph was taken in 1839. In the years that followed, photographs became much easier to take and to print (using sheets of specially prepared paper).

- **Deborah Smith** (born in Hastings, 1962), *Esther with Camera*, 2015

For most of the camera's 180-year history, this box-like contraption contained a roll or sheet of film upon which images were recorded. Since the arrival of digital technology, images have mostly been recorded onto a memory card. The glass eye-like window – the lens – through which the photographic image enters the camera hasn't changed much; neither has the shutter which opens with the push of a button.

How is a photo made? It begins with light entering the front of the camera through the lens when the shutter opens. (The moveable parts of the shutter are appropriately called 'the blinds'.) Light travels through to the film (in an old-style camera) or the electronic sensor (in a digital camera), where the photographic image is recorded. This is called an 'exposure'.

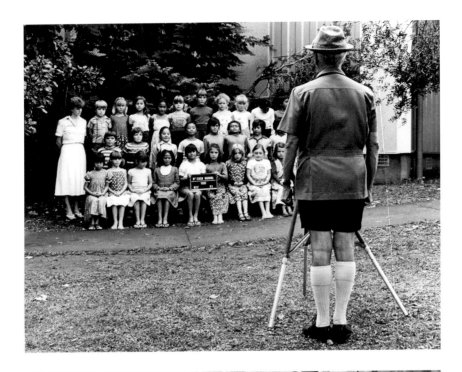

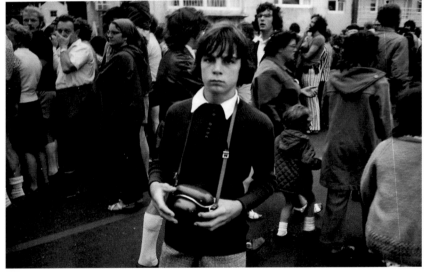

These days, the camera is able to do a lot of the thinking for you. It can read the light in the room or outdoors, and it adjusts the exposure accordingly; it works out the distance from its subject. It pays attention and makes adjustments. Many photo-artists, however, still like to do lots of the technical work themselves – to get the kinds of exposures that they want.

Whether using new or old technology, the photo-artist always has to make important choices: what to include and what to leave out of the photograph. They have to decide what to focus on, how far to be from the subject; when exactly to press the shutter release . . . Later, when developing the film or printing the image, other adjustments can be made. The framing of the image might be altered; the colour enhanced (or a colour photograph might be rendered as black and white).

- **Marti Friedlander** (born in England, 1928, arrived in New Zealand 1958), *Mt Eden Normal Primary School, Valley Road*, 1981
- **Lucien Rizos** (born in Wellington, 1953), *Wellington*, 1974

'Photos are made of a camera and people.' – Franka Moleta, aged 4

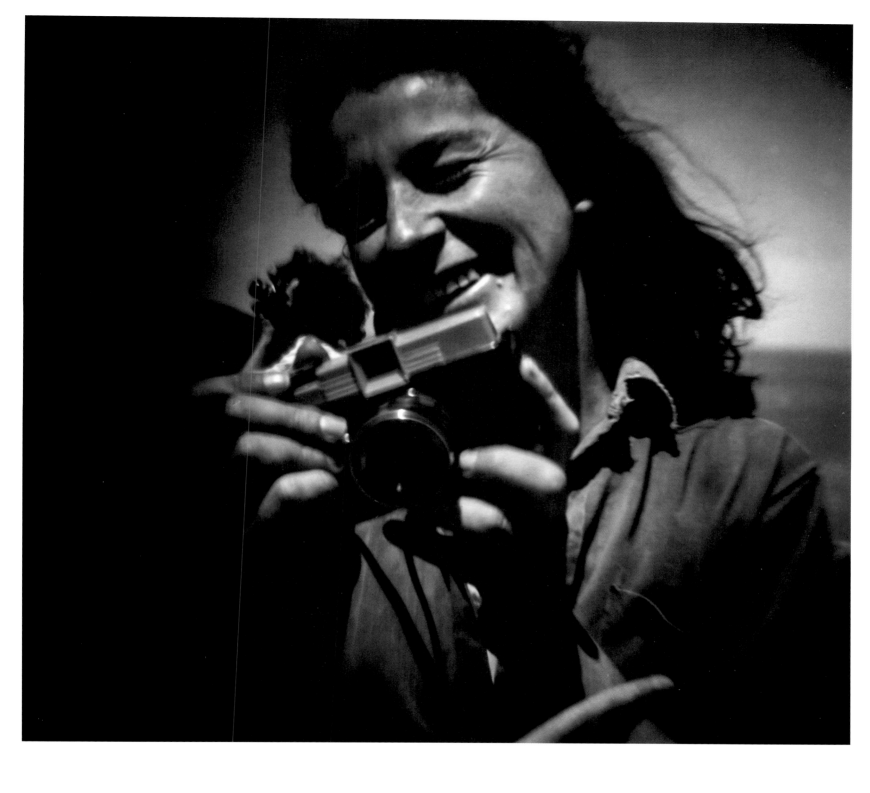

• **Peter Black** (born in Christchurch, 1948), *Leslie and Diana Camera*, 1979

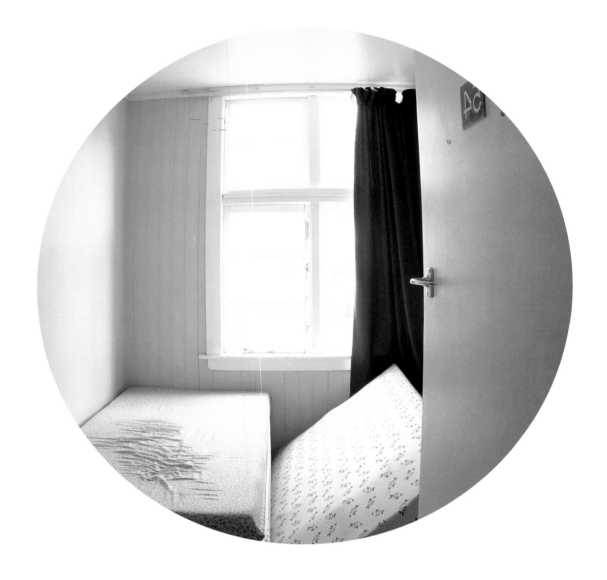

The word 'camera' comes from the Greek and Latin words meaning 'a room' (in which people live) or 'a vault' (in which things are stored or locked away). When you think about it, cameras resemble both those things. And photographs, too, are places where some things are revealed – as in a room – while other things might be hidden – as in a vault. Some really good photos are both these things at once.

• **Ann Shelton** (born in Timaru, 1967), *Phoenix block, room #54*, 2008

We live in a world which is busy with cameras. Everywhere we look, photos are being taken on mobile phones, security cameras, speed cameras installed alongside busy roads, and x-ray cameras at airports or medical centres. There are disposable cameras, cameras with telephoto lenses, panoramic cameras, party cameras that make everything go crazy colours . . .

While technology has made photography much easier and more versatile, some artists continue to use old-fashioned equipment rather than the latest high-tech devices. Other photographers prefer the most basic equipment they can find – or make their own.

Artist Robin White (see page 17) makes pinhole cameras out of matchboxes (with a hole poked in the front for a lens) and pieces of sticky tape. So does Darren Glass. He has constructed home-made cameras using the most unlikely objects: acorns, Frisbees, pāua shells and even baked pies. In his book *A Field Guide to Camera Species*, he seems to be saying that just about any hollow object can be turned into a camera.

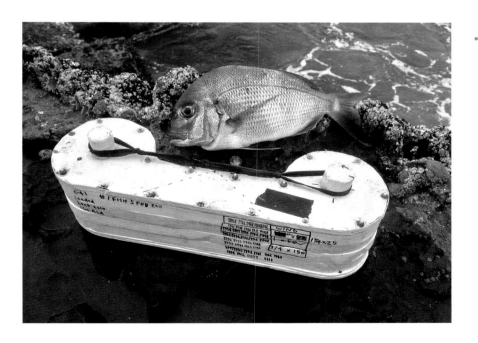

- **Darren Glass** (born in Auckland, 1969), *Every Fish I Caught Cam (Fish Cam)*, 2005. Made of metal, cardboard, fibreboard, pine, rubber, tape and glue, Darren's 'Fish Cam' houses a roll of film upon which he records the day's catch. Darren takes this device with him whenever he is travelling around the fishing spots of Northland. For him, the art of fishing and the art of photography are very closely related – both are dependent on the seasons, the weather and being in the right place at the right time.

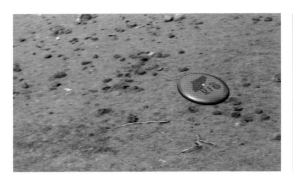 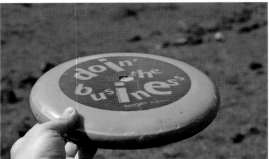 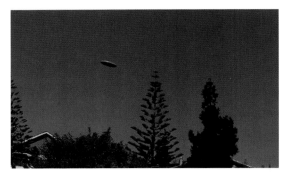

Among Darren's more outlandish devices are his Frisbee cameras, which he first started developing and experimenting with in 2000. He began with a Cosmo Flying Disc (purchased from The Warehouse), which he made into a 'flying pinhole camera' by drilling holes in it and adding a lightproof cardboard insert, containing film. 'The "Cosmo" is loaded with film in the darkroom or change bag, then stored in a lightproof bag,' he says. 'When conditions are right I remove the camera and throw. The camera is retrieved from its landing place as soon as possible and returned to the lightproof bag.'

(Darren's airborne cameras aren't the only such devices spinning or flying through the air above us. The number of satellite cameras and aerial surveillance devices has been increasing rapidly in recent times. In the middle of an international cricket match during the summer of 2015, one overhead camera-drone, buzzing around above the pitch, was attacked by a flock of irate seagulls.)

Not only are Darren's home-made cameras fascinating objects/sculptures in their own right, the resulting photographs are often like nothing you will have seen. Sometimes they are made up entirely of lines or splashes of colour, streaks of light and flashes. Like a scientist in a laboratory, Darren treats each new photographic assignment as an experiment. He works out a few things, then steps aside to see what his hand-made cameras will come up with. The fact that the images are often blurred or out of focus creates an unsettling and weird (and sometimes beautiful) effect. Maybe his photographs are closer to abstract paintings than to your usual photographs?

- **Darren Glass,** *Disc UFO*, 2005, *doin' the business*, 2005, and *Cosmo Flying Disc*, 1999
- **Darren Glass,** nine images from the series 'Cosmo Flying Disc', 2000–

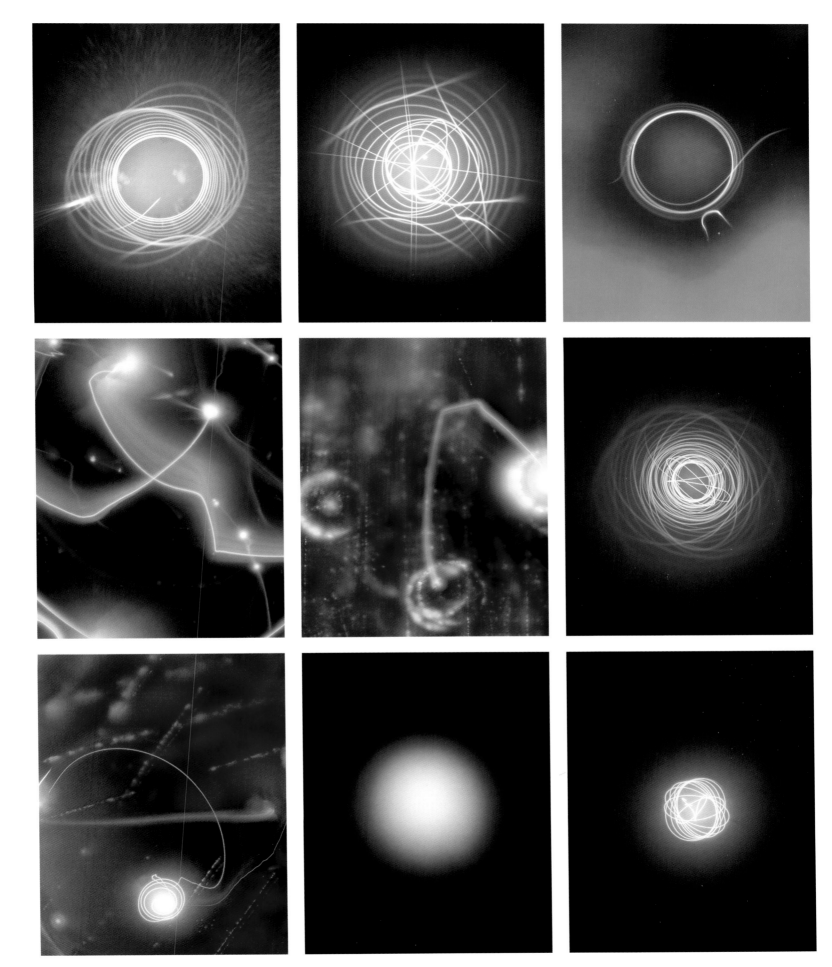

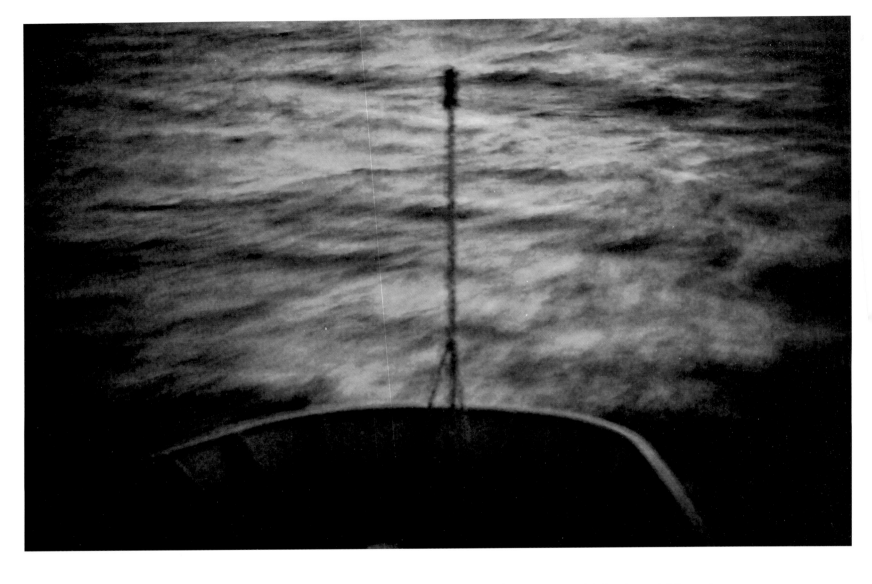

When Jason O'Hara took this photo of the ocean (nearing Raoul Island, 1000 kilometres north of mainland New Zealand), I was standing on the foredeck of the HMNZS *Otago*, just out of the shot. When I finally saw Jason's picture I was struck by how he had captured how it *felt* rather than how it *looked* as we approached the island. It was five in the morning and we had just come through a storm. The world seemed a gritty, grainy, dark and damp place. And it felt as if we had travelled back in time.

To his brand-new Nikon camera, Jason had attached a lens salvaged from his grandfather's Kodak Vest Pocket Autographic – a camera dating back to 1915. The end result is an up-to-the-minute digital photograph which looks as if it might have been taken a century ago. It is almost as if he is seeing things through his grandfather's eyes.

• **Jason O'Hara** (born in Palmerston North, 1968), *Sea change (approaching Raoul)*, 2011

Also on that voyage to the Kermadec Islands was Robin White. While at sea, she sat in the officers' mess making cameras out of match-boxes and black tape. Using slightly more sophisticated equipment, a plastic 'Holga' pinhole camera which she bought over the internet, she took two pictures at Denham Bay on Raoul Island.

'There is no view finder,' she says. 'You just have to point the camera in the right direction and hope for the best. There is a small spirit level indicator on the top of the camera so you can at least see if it is level. Everything else – angle, framing up, distance, shutter time – is all guess work . . . It was extra tricky because the beach was on an angle and the wind was blowing.' These photographs taken from ground-level convey a feeling of being washed-in or having just stepped ashore.

The photographs by Jason and Robin both have a sense of seeing something for the first time. In these images, the present moment seems strangely distant and long ago; and the past seems very present.

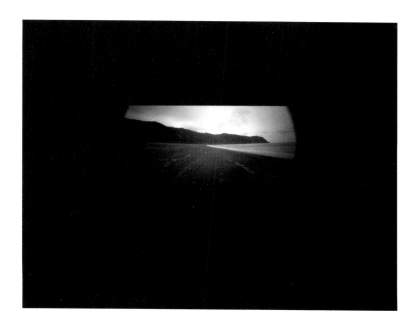

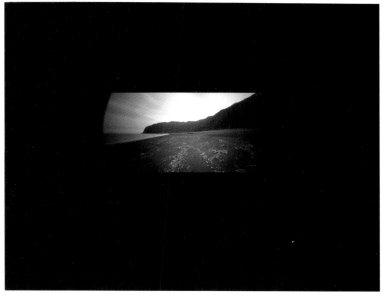

• **Robin White** (born in Te Puke, 1946, Ngāti Awa), *Denham Bay, Raoul Island*, 2011

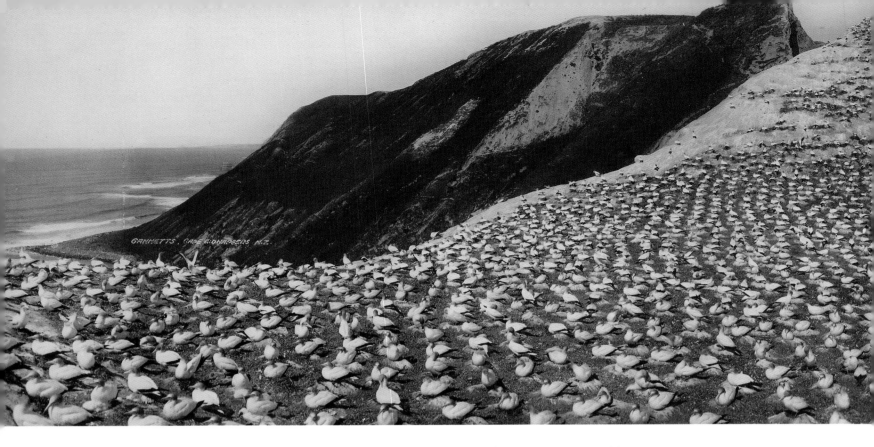

- **Robert Percy Moore** (born in Christchurch, 1881, died 1948), *Gannetts, Cape Kidnappers, N.Z.*, 1920s

As early as the 1840s, there were lots of photographers – professional and amateur – snapping away in New Zealand. Photography went on to record just about every major development in this country's history through the period of settlement, on into the twentieth century, and now, full steam, in the twenty-first century.

Taken on a panorama camera which rotates atop its tripod as the exposure is being made, R. P. Moore's photograph of gannets at Cape Kidnappers was hand coloured – a process which usually involved cotton tips on toothpick sticks. Moore is best known for his photos of cityscapes and large groups of people documenting life in the early twentieth century. For more than 150 years, photo-portraits have also provided an essential record – although on a narrower stage. In the 1870s, Samuel Carnell photographed Huhana Apiata, with traditional moko, dressed in fashionable European clothes.

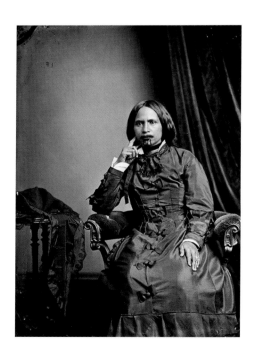

18

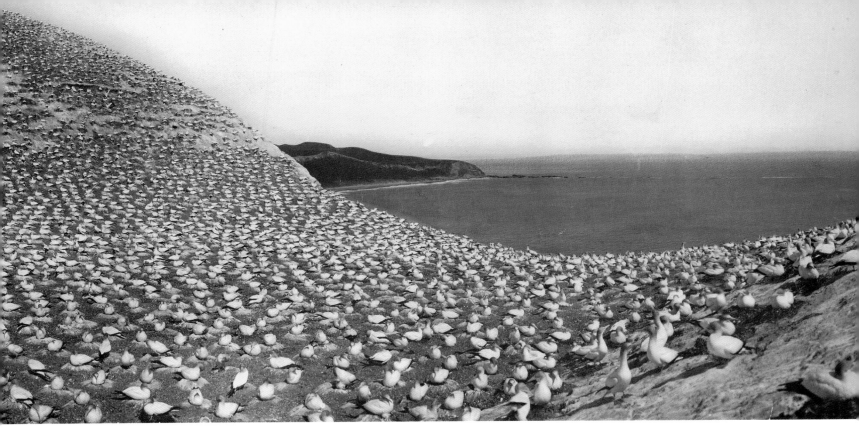

In contrast to Samuel Carnell's staged and formal portrait, John Pascoe's portrait of a tractor-driver captures a moment in the everyday life of a feisty, determined woman. Taken during World War II, the photograph records the fact that, at a time when many New Zealand men were overseas in the armed forces, women had to step up to run the farms and businesses. In their different ways, the photographs of Samuel Carnell and John Pascoe both offer a sense of the dreams and aspirations, the pride and the character of their subjects.

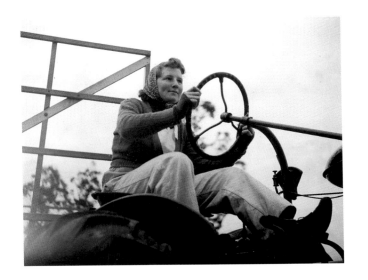

- **Samuel Carnell** (born in England, 1832, arrived in New Zealand 1862, died 1920), *Portrait of Susan Jury (Huhana Apiata)*, 1870s

- **John Pascoe** (born in Christchurch, 1908, died 1972), *A female linen flax worker driving a tractor in Geraldine*, 1943

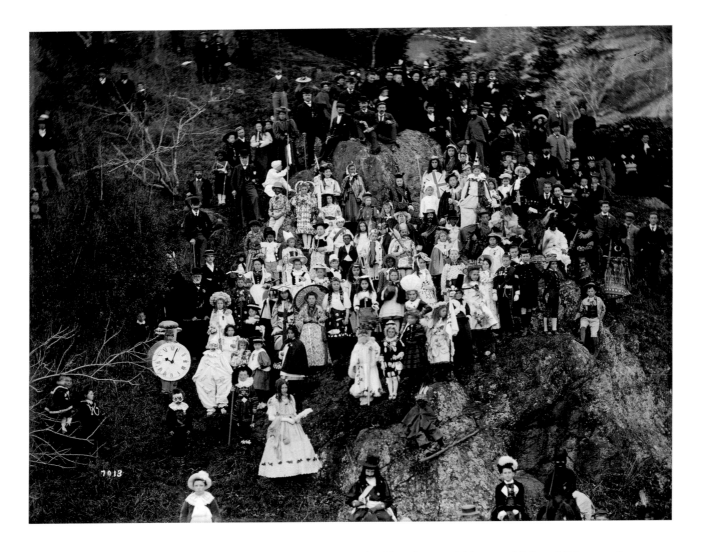

When we look at old photographs we enter the world of those being photographed. Sometimes it seems like the people in the photo are returning our gaze; they look forwards in time towards us, often with the same sense of puzzlement we have when looking at them.

When Edwin Pollard captured this impressive crowd of children in outlandish costumes, he used a large, cumbersome camera secured on a solid three-legged tripod, to minimise the wobbling. (Because of the time needed for the image to register on the film, he would have told the children to keep still while the photo was being taken. However, despite their best efforts, there are some blurred faces and limbs in this photograph. Look closely and you'll see.) Next, he would have disappeared beneath a cloth behind the camera to release the shutter (just like the photographer on page 107).

- **Edwin Pollard** (born in London, 1855, died 1905), *Participants in Nelson celebration of Queen Victoria's Diamond Jubilee*, 1897

Until a few years ago, people used to say 'the camera never lies'. If the man in the photograph below had simply told his friends about the giant cabbage, no one would have believed a word of it. This photograph is as good a proof as you could get. However, in this era of digital effects, it has become much easier to alter photos. These days, we never take it for granted that the camera is telling the absolute truth.

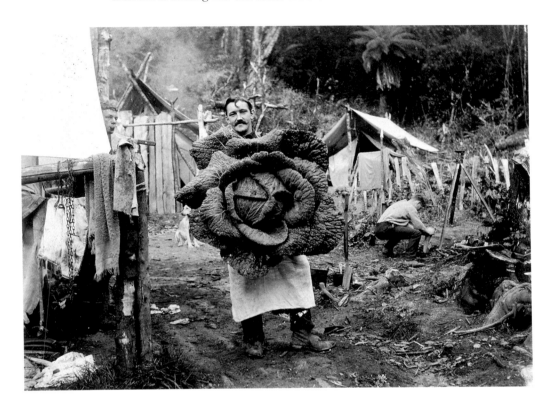

Photographs speak to us of the times in which they were taken. Once you look beyond the Giant Cabbage, you'll find that this photo has a lot to say about life in New Zealand during the early days of European settlement. You learn that men of this time (often with strangely exaggerated moustaches) lived in tents and ramshackle structures in and around native bush. They were fond of dogs (there's one peering from behind the cabbage). Life was muddy, dusty, smoky and, for much of the time, uncomfortable. In the midst of all this, the giant cabbage must have lifted their spirits – and hopefully the cook, in his apron, made a great meal from it.

- Photographer unknown, *The camp, the cook and the cabbage, Wairarapa*, 1890s

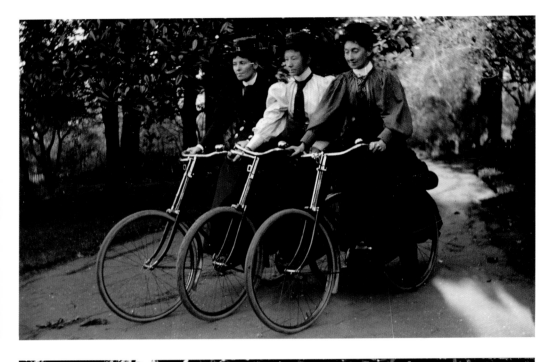

Photographs should not always be trusted. When Margaret Matilda White photographed her three friends riding their bicycles, she asked them to hold still and *pretend* to be moving. (If you look at their hands, you will realise the bicyclists are holding each other up. They are not moving at all.) If they had been riding along at speed, they would have been blurred in the photograph.

In the second image, the three friends are pretending to fall over. It's all a clever game. But whether the photographs are 'real' or not doesn't matter – they tell us about Margaret's character and those of her interesting, spirited friends.

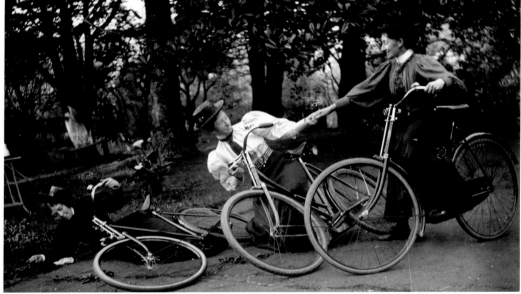

- **Margaret Matilda White** (born 1868, died 1910), *Three nurses riding bicycles, Auckland Private Hospital* and *Three nurses on bicycles falling over, Auckland Private Hospital*, c. 1900

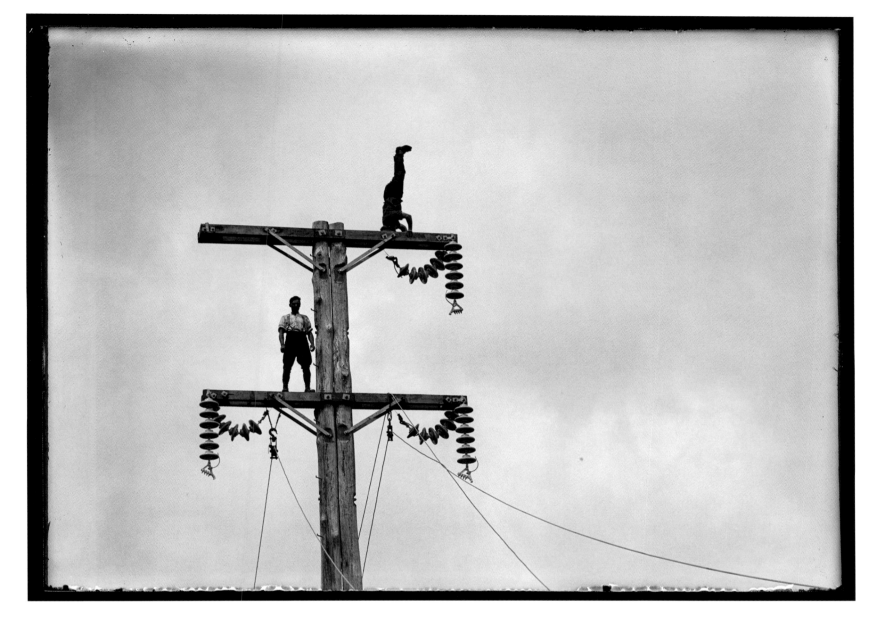

Here's a fact: the presence of a camera can make people do unusual things, things you wouldn't normally expect of them. Think of Margaret Matilda White's bicycling girl-friends, or of the two workers in Leslie Adkin's photograph above. While photographs provide a documentary record of the nation's history, some of the greatest, most telling images capture moments when people are relaxing, letting off steam or are just in high spirits. New Zealanders pride themselves on their hard work and big ideas, but they are also risk-takers, acrobats, mischievous types, people intent on turning the world upside-down . . .

• **Leslie Adkin** (born in Wellington, 1888, died 1964), *Mangahao – Wellington city transmission line*, 1923

One of the most widely taken kinds of photograph in the world today is the 'selfie'. Earlier generations might have called this a 'self-portrait'. Selfies are photographs you take of yourself, usually by holding the camera at arm's length, with the lens pointing back at you. 'Selfies' often involve getting someone else in the shot – if you're lucky, an All Black or a Rolling Stone or the Pope, or maybe even Lorde. (Most selfies are only ever seen on the screens of mobile phones or computers – they don't make it as far as photographic prints.)

In fact, people were taking 'selfies' a long time before digital cameras. As if she was heading off to a fancy-dress party, Margaret Matilda White donned an exquisite Māori cloak and had a moko drawn on her chin for the 'selfie' on the left, which she took using a timer on her old-style camera. Compare this portrait with that of Huhana Apiata on page 18. Both photographs were taken at a time when Māori and Pākehā were trying to work out how they fitted into each other's worlds.

- Mark Smith, *Jack with open mouth*, 2014
- Margaret Matilda White, *Margaret White dressed as Maori*, c. 1900

24

- **Lisa Reihana** (born 1964, Ngāti Hine, Ngāpuhi, Ngāti Tū), *Hinewai*, 2001.
 Hinewai is from a series of mythological 'portraits' in which Lisa Reihana
 imagines Māori gods as people in the modern world. Hinewai – whose
 name means 'water girl' – is the personification of light, misty rain.
 Although Lisa Reihana looks to ancient traditions for her inspiration,
 her subject is presented in a manner which is high-tech, futuristic and
 more than a little glamorous.

Look at me look at you

A camera is a machine for remembering things, or for thinking about things differently, or even for inventing things. But first, though, it is a machine for seeing. See what I can see. You might be seeing something that I haven't seen, or didn't notice, or couldn't recognise?

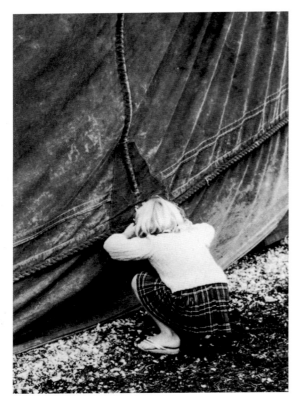 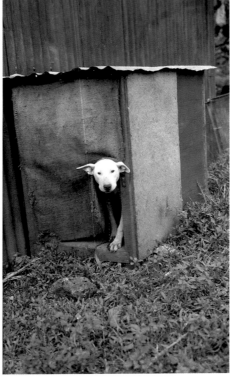

Photography is all about looking. In Thelma Kent's photograph, a dog emerges from behind the curtain to return the photographer's gaze. What does the girl in Ans Westra's photograph see when she stares through the gap in the tarpaulin? The title of the photograph is *Sole Bros & Wirth's Circus, Newtown, Wellington*, so we know this is a circus tent, with all kinds of tricks and surprises happening inside. Just as the girl is spying on the circus, the photographer is spying on the girl. And we, the viewers, are spying on both the photographer and the girl.

- **Ans Westra** (born in Leiden, the Netherlands, 1936, arrived in New Zealand 1957), *Sole Bros & Wirth's Circus, Newtown, Wellington*, 1966
- **Thelma Kent** (born in Christchurch, 1899, died 1945), *A dog poking its head out of a kennel*, c. 1939

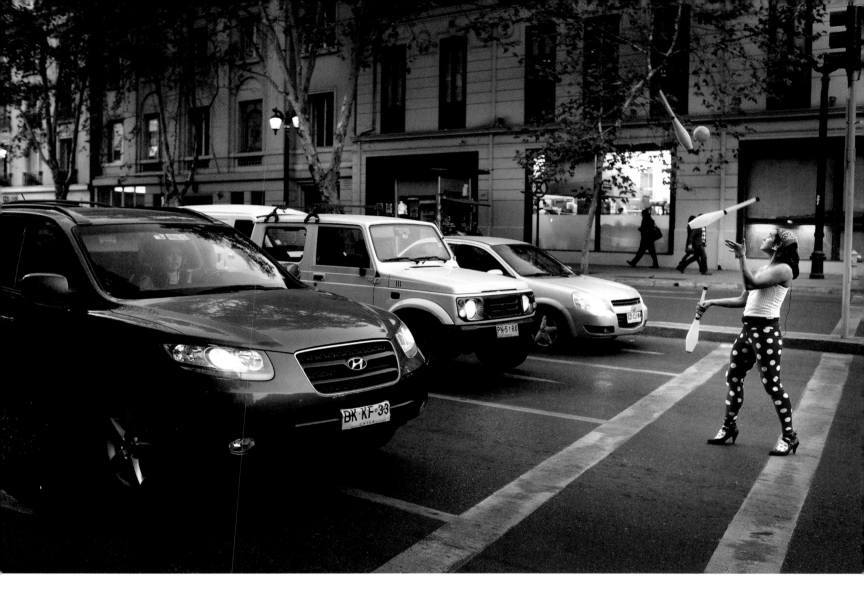

• **Bruce Foster** (born in Whanganui, 1948), *Juggler, Santiago*, 2013. It was twilight in the bustling South American city of Santiago. Photographer Bruce Foster and I were crossing a road when a woman in spotted leggings ran out in front of us. And then the show began. Every time the lights went red she would perform – on a unicycle or juggling or both at once. Then she would whisk around the cars to collect money from the drivers. All of this happened within about ninety seconds. (To get the shots he wanted, Bruce had to move nearly as fast as the performer.) In Bruce's photograph, the cars' headlamps are the stage lights, illuminating the ball and clubs, and the luminous face of Carolina, the tireless busker.

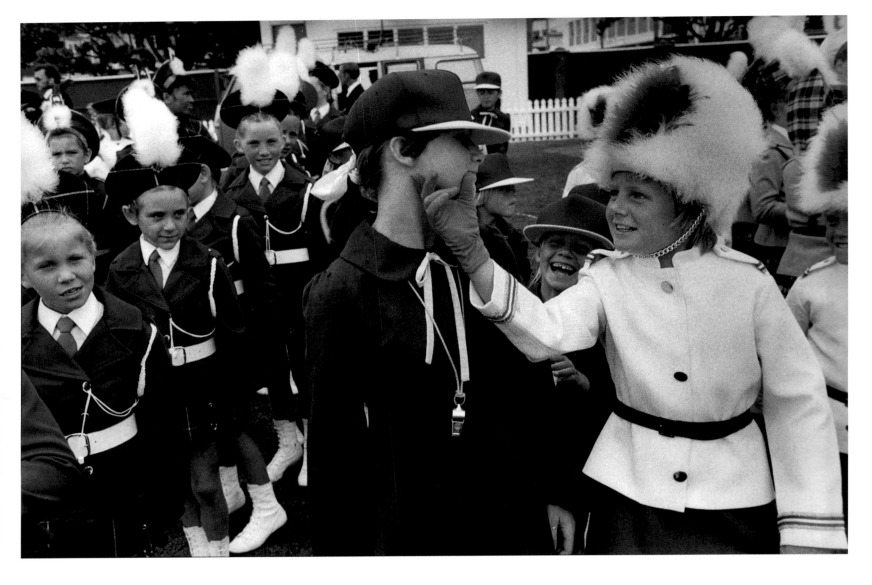

Who are the girls in Peter Black's photograph? Is the girl in the white uniform one of the team – or, more likely, is she from the opposition? The expressions of the onlookers suggest all kinds of emotions. Maybe the girls are about to perform and they are nervous? Or maybe they have just won the competition? Photographs have plenty to tell us about the world. Yet they are often full of mystery and complication. They can change every time you look at them. The longer you spend with a photograph, the more you see and – sometimes – the less sure you are about what is actually happening.

For most of his career Peter Black only took black-and-white photographs. He said in an interview: 'For thirty years I saw the world in black and white – I'd go down the street and not see colour because I didn't need to see it . . . When you're looking at a black-and-white photograph maybe you're in touch with something a little uncanny . . . you're looking at something that is a dream, or it's in the language of a dream.'

• **Peter Black,** *Marching Girls, Wellington,* 1985

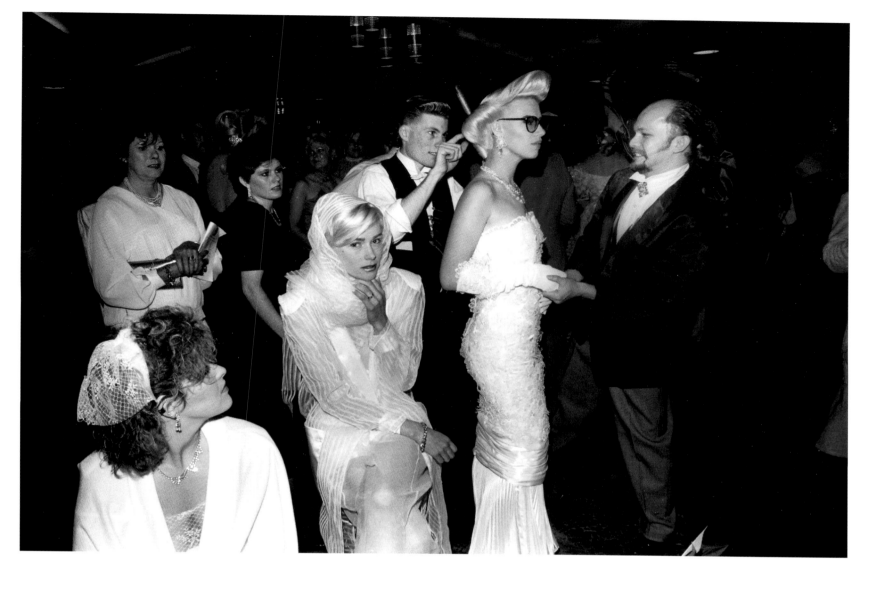

- **Peter Black**, *Hairdressing Competition, Wellington*, 1985. People always want to look good in photographs – especially at fashion shows or formal occasions. Maybe Peter Black's *Hairdressing Competition* records a glamorous event. Or might it be a disastrous or embarrassing moment in someone's life? And the bearded and bow-tied man on the right – is he an actual hairdresser, or a competition judge, or the Master of Ceremonies? One seated girl, wearing a veil, looks towards the photographer, as if to ask what right he has to be here. Photographs are very good at asking questions. Perhaps they are better at questions than at giving answers?

Photography is about looking beyond the obvious and finding things that are hidden away. When Victoria Birkinshaw photographed a touring circus she didn't confine her photographs to the main stage during a performance. She stayed long after the show had finished, exploring the outskirts of the circus camp. Victoria followed the circus around Paraparaumu, Porirua and the Hutt Valley, getting to know the performers and the animals. She photographed them offstage, and outside of performance hours. Her photographs take us on a tour of their personal lives and the places where they practice and relax and wait around. And it is every bit as amazing as anything that happens on stage.

Victoria Birkinshaw's photographs tell a story without using words. A sequence of pictures like this is usually called a 'photo essay'. One image follows another. Each image comments on the others that come before and after it.

- **Victoria Birkinshaw** (born in Yorkshire, England, 1978), from 'The Circus' series, 2003

In 1999 photographer Alan Knowles was commissioned to produce a series of photographs of the Griffin's biscuit factory in Lower Hutt. Not the most exciting assignment, you might think. But as soon as Alan began taking pictures, he realised that the potential was limitless. As well as photographing the workers, he looked at the machinery of the production line and he took close-up images of the biscuit-materials.

The photographs came together to create a picture of all the ingredients that go into the finished biscuits: not only flour and sugar and water, but also hard work, ingenuity and clever technology. He paid particular attention to the design and lettering – the patterns and words which are stamped on the biscuits before they harden.

The moral of the story, according to Alan, is that even the most ho-hum things can become great photographs. Work on it!

- **Alan Knowles** (born in Queenstown, 1948), from 'Biscuits Series', 2001

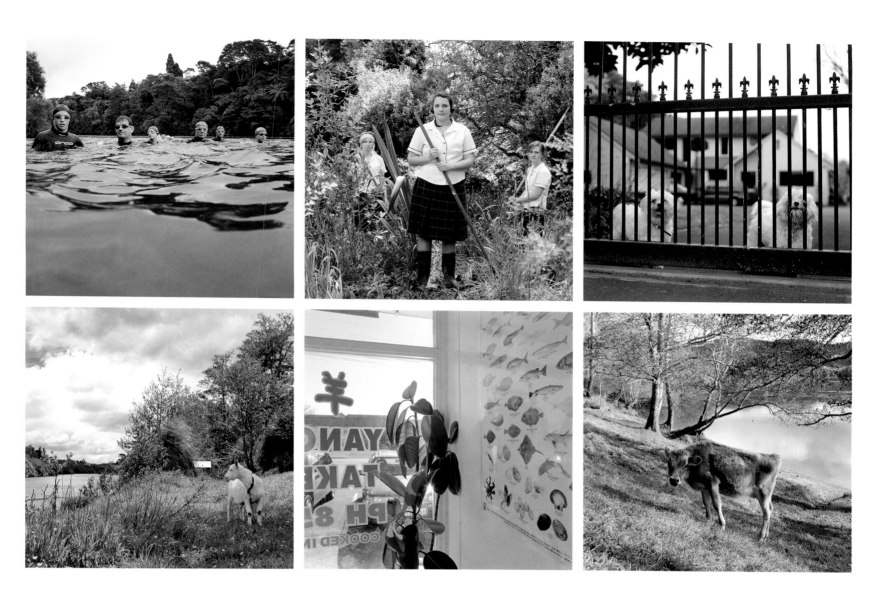

- **David Cook** (born in Christchurch, 1959), from 'River / Road', 2007–2010. Interesting things wash up on the banks of a river – not only objects, but also animals, fish and people. For his photo essay 'River / Road', Hamilton-based David Cook collected images from alongside both the Waikato River and the River Road, which runs parallel to it. David went exploring. He recorded the natural world, the world of human-made things and, of course, the world of humans. 'River / Road' was eventually published as a book, with short texts to accompany each of the photographs, stitching together a rich narrative of riverside life.

While colour photography was pioneered back in the late nineteenth century, it wasn't until the 1930s and '40s that the use of colour film became widespread. Why is it that black-and-white photographs have such a different feeling to colour pictures? Maybe it is because colour photographs can replicate the world pretty well, whereas black-and-white images translate it into another kind of reality. Maybe a black-and-white photograph is like a drawing, whereas a colour photograph is like a painting?

In Greta Anderson's 'Colour Box', the subject of the pictures is colour itself. The three photographs are like a poem in which something yellow is placed alongside something red (and green) and, finally, a blue thing. Perhaps these three photos are pages from her diary – three scenes she encountered while out walking and liked the look of. A photo sequence doesn't have to lead in any obvious direction and, in this case, Greta doesn't want to tell us a story. She has simply presented three images. Each has its own life and – when grouped together – the three have a curious shared life.

- **Greta Anderson** (born in Auckland, 1968), 'Colour Box', comprising three photographs: *Little Yella, Whanganui*, 1999; *Letterbox, Grey Lynn*, 1994; *Parnell Pool*, 1994

These days, most good-quality cameras can take moving footage as well as still images. Photography and cinematography (or movie-making) have never been this close before. Just as photo-artists including Anne Noble, Gavin Hipkins, Bruce Foster and Nova Paul have presented movies and video-works in galleries, many film- and video-makers also exhibit still images. Following in that tradition, filmmaker Florian Habicht is an energetic creator of moving and still compositions – on the big screen, and then translated into single, stand-alone images – some of which are taken by himself or, as is the case here, by photographers on set including his father, Frank, and collaborator-friend, Maria.

• **Florian Habicht** (born in Berlin, Germany, 1975), stills from *Love Story*, 2011 (photograph by Maria Ines Manchego), and *Kaikohe Demolition*, 2004 (photograph by Frank Habicht)

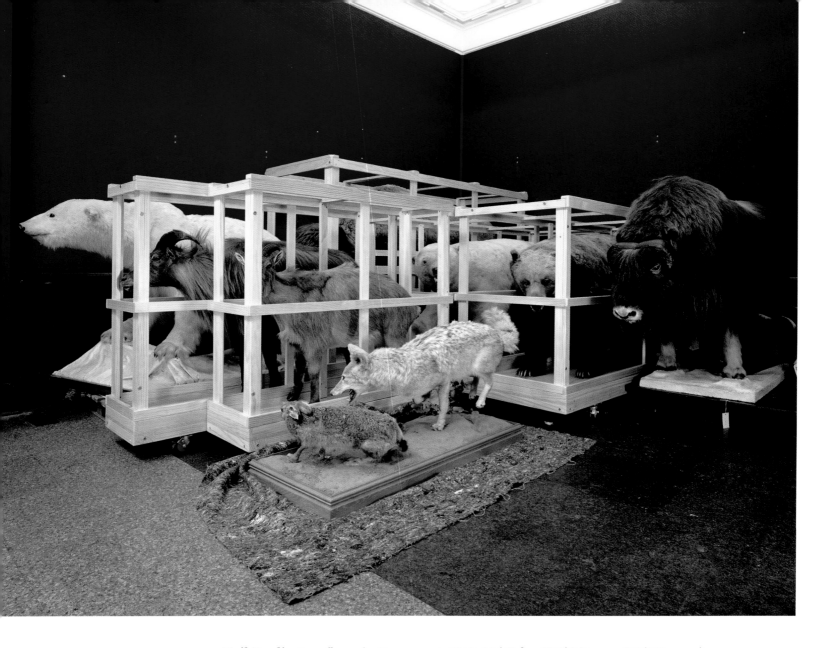

- **Neil Pardington** (born in Devonport, 1962, Kāi Tahu, Kāti Māmoe, Kāti Waewae), *Large Mammal Storage Bay #1, Canterbury Museum*, 2007. As we have seen, one of photography's greatest tricks is its ability to freeze a moment, to stop time. It can render stillness in a world that is always on the move. Neil Pardington's photograph of a storage room in Canterbury Museum, however, does the exact opposite. The animals in his photograph are mounted and stuffed ('taxidermised', some might say). In the back room of the museum, these once fearsome or gracious creatures are packed away. Yet Neil's photograph somehow brings them back to movement and life. The animals are all facing in the same direction – like a migrating horde. There is a sense of reawakened movement and purposefulness. Onwards.

A thing or two

The camera sits on a table or it stands on three legs. Most often it is held or cradled in two hands. The camera looks at the objects around it. Maybe it feels especially at home in a world of objects: a block of cheese shaped like a house, a toy racing car . . . The camera can bring the plainest of objects to life.

The simplest things can be the best subjects. Frank Hofmann photographs a tiny car on an angle to hint at it speeding along; the lighting is stark and spacey. Peter Peryer's little rabbit is boxed in by the edges of the picture. The black of its eye and shadowing contrast with the fuzzy texture of the fur. He photographs the tiny creature as though, for a moment, it is the most important thing in the world.

- **Frank Hofmann** (born in Czechoslovakia, 1916, died 1989), *Toy Car*, c. 1948
- **Peter Peryer** (born in Auckland, 1941), *Rabbit, Lightning Field, USA*, 2000

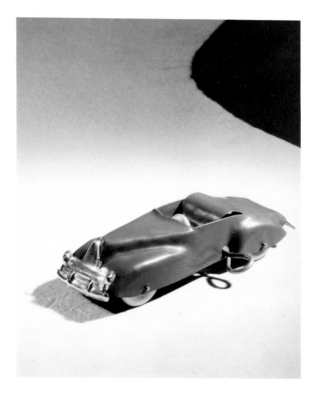

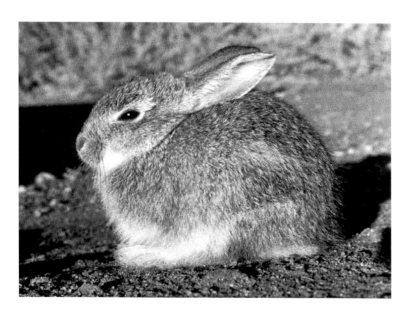

Peter Peryer's rabbit, frozen in place, reminds me of an old rabbit-hunters' trick my uncle John would do. If he spotted a rabbit, he would put his fingers to his mouth and make a high-pitched whistle. The rabbit would freeze and pull its head in, and not move as long as he kept on whistling. As kids, we were spellbound. Photography and my uncle John have this in common: they can both freeze a rabbit.

- **Peter Peryer,** *Ice Cream*, 2007–2009. 'My photographs are self-portraits,' Peter Peryer says, whether he is photographing himself holding a rooster (as he did in a 1977 image) or capturing the bendy form of a dropped ice cream cone. What does he mean by this? Do the photographs tell us how he is feeling or what makes him tick? Peter explains, a little: 'The photographs are somehow related to my past. I don't know how or why . . .' If each photograph is a self-portrait, then all the pictures Peter Peryer has taken over the past forty years add up to a kind of autobiography. They are the story of his life, seen through his eyes, seen through the lens of his camera.

A camera is dropped onto the ground and the shutter clicks. A camera on a tripod is bumped; a timer misfires. Photos go wrong. The light shifts, or the subject blinks or sneezes or looks to one side. The dog disappears back into its kennel; a bird takes flight . . .

One of the great pleasures and beauties of photography is its capacity to turn accidents or mishaps into opportunities. And sometimes mistakes can be the best kind of photographs. Gabrielle McKone was taking a photograph of a bird atop a rubbish bin when, just as she went to click the shutter, the bird flapped its wings. The result is a photo of a missed moment – but it's probably a better photograph than a bird on a rubbish bin could ever be. Accidents do happen, and this adds another layer of life to photography.

• **Gabrielle McKone** (born in Oamaru, 1954), *Marine Parade 16-09-07*

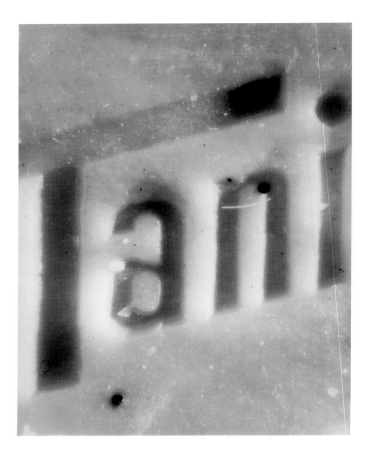

As well as reproducing the world, photography can show it in a new and often curious light. Fiona Pardington has taken photographs of the most ordinary things: a stuffed bird on a museum shelf, a pāua shell, the kinds of things you would find in the bathroom cupboard . . . *Taniwha* is a close-up of a block of soap upon which a brand name has been stamped. When letters and words find their way into photographs, the acts of looking and reading come together. A 'taniwha' is a Māori river spirit, but how is that relevant? Is she telling us something, or is she just exploring the marvellous ability an old cake of soap has to absorb and refract light?

When Gavin Hipkins exhibits his photograph *The Oval*, he prints up a large version of it – usually 100 by 80 centimetres. This puzzling image is even more disconcerting when it is much bigger than life-size and behind glass on a gallery wall. In fact, Gavin's subject is a soap dish which he had bought from a $2 shop. In this carefully, brightly lit photograph, the soap dish becomes something else – a weird life form or science experiment.

- Fiona Pardington (born in Auckland, 1961, Kāi Tahu, Kāti Mamoe, Kāti Waewae), *Taniwha*, 1995
- Gavin Hipkins (born in Auckland, 1968), *The Oval*, 1998

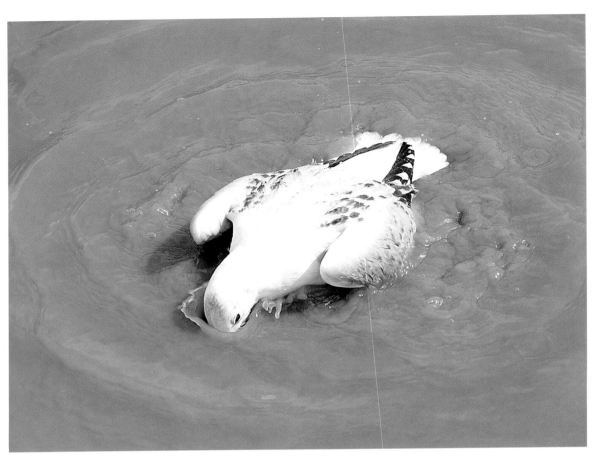

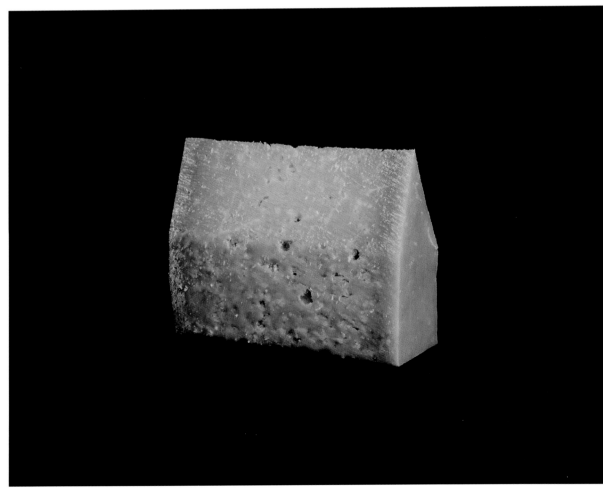

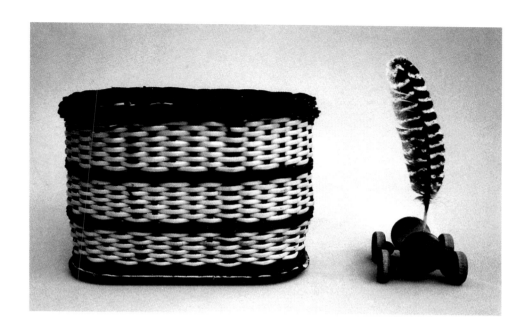

While Greta Anderson's seagull gulping muddy water and Marie Shannon's cheese house are instances of a photographer looking closely at a single subject, other kinds of surprises and revelations can occur when you bring two things together within a single photograph. The result can be a *conversation* between things that don't normally speak to each other. In Peter Peryer's *Still Life,* two objects are presented together, as if on a small, blank stage. What do these objects have in common, apart from the fact they are both in Peter's photograph? In Fiona Pardington's *Taniwha,* on the previous spread, the photographer has divided a single object into two, creating yet another kind of dialogue: two halves of an object hanging next to each other on a wall.

- **Greta Anderson,** *Seagull in brown water, Port Chalmers,* 2014
- **Marie Shannon** (born in Nelson, 1960), *The House of Parmesan,* 1981
- **Peter Peryer,** *Still Life,* 1982

When you put two different pictures alongside one another, they talk to each other – sometimes they argue, or they get along just fine. These two photographs by Gabrielle McKone are totally different in subject matter – yet the shapes within the pictures are very, very close. The large rectangular forms descending from the top of both photographs form a visual rhyme. And so the two images strike up a conversation.

These photographs first appeared on Gabrielle's website. Every day for the past eight years, she has photographed her family or any old thing she comes across. She made her first posting on 14 August 2007, so she has published well over 3000 images to date.

• **Gabrielle McKone,** *Llafranc 07-06-09* and *Church St 21-03-11*

One of the family

A photograph is a way of saying here we are – *and, later,* there we were.
A moment passes, and photographs are one way of holding on to time as it goes by.

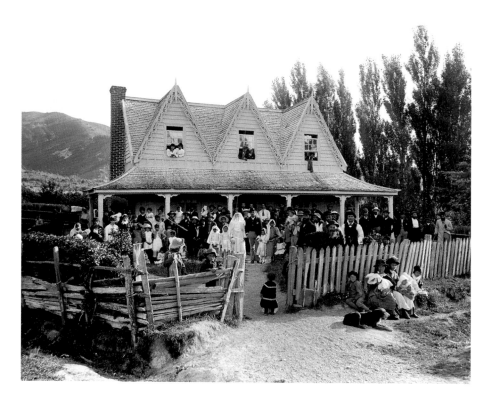

Cameras follow us through life. Wherever you see a bride and groom – outside a church or getting into a car or posing in the rose gardens – you'll nearly always see a photographer. It's hard to imagine a wedding without wedding photographs. Cameras attend most of the great moments in your life – births, weddings and funerals and all the things between: the winning try in a rugby match, the piano recital, the school ball, the birthday party . . .

While plenty of wedding photographers are content to take a portrait of the Happy Couple in a well-tended garden or on a sparkling lawn, this wedding photo by the Tyree brothers takes a wider view. This is as much about a community of people – friends, family, tribe – as it is about the newly-weds. The photograph includes the house they inhabit, the trees and hills behind – and the picket fence, with unruly children in the foreground. And it captures a time – 1896 – when New Zealand was visibly changing.

• **Frederick Tyree** (born in London, 1867) and **William Tyree** (born in Surrey, 1855) (both arrived in New Zealand 1871 and died 1924), *Love Wedding, Waikawa Bay, Picton,* 1896

45

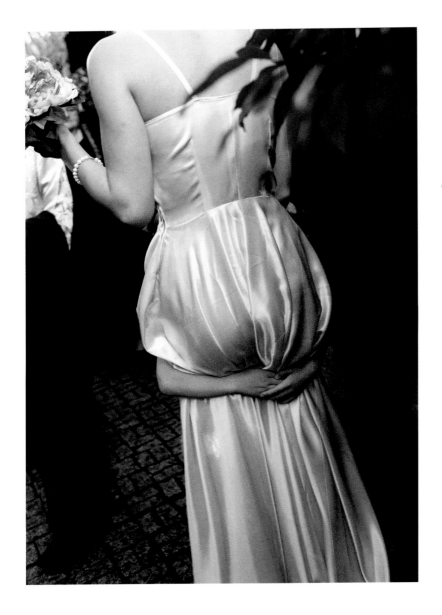

• **Bruce Foster,** *Penny, Sydney,* 2008. In most wedding photographs, the photographer makes sure the top edge of the picture-frame isn't chopping anyone's head off. Not so, here. Bruce Foster's photo is a decidedly 'unofficial' wedding photo. He concentrates our attention on the surface of the bride's glowing silk dress and on the arms which reach around to embrace her. Not a single face is in sight. The picture speaks of relationships between people – adults and children. It breaks all the rules of usual wedding photography. Yet it is filled with the kind of love and tenderness that conventional wedding photographs rarely capture.

The camera remembers how you looked and how you were feeling.
It remembers your face. And it remembers people you met and things
that happened to you.

One of the first things that happens in your life is a photograph. After you are born, a family member or a nurse is given the task of pointing a camera at you. And so the strange box finds itself involved in the most private and special moments, snapping away, making itself useful (and hopefully not being a nuisance).

After being born, growing up is photography's next great theme. Since the nineteenth century, parents have marched their little ones along to photographic studios to have formal portraits taken.

Of William Harding's portrait of Mrs Morgan and her child (on right), conservator of photos Mark Strange says: 'It probably would have been the first time they had encountered a camera or had a lens pointed at them. The exposure would have taken about four to eight seconds, depending on how bright the day was.' Mrs Morgan is, according to Mark, trying to ensure her child doesn't move while the exposure is being made. The finished portrait would have been cropped so only the child was visible.

- **Mark Smith,** *Jack, 20.04.07*
- **William James Harding** (born in Southampton, England, 1826, died 1899), *Mrs Morgan and child,* 1870s

Len Lye's photograph (on right) isn't so much about the birth of a single baby – we can't make out any distinguishing features – it's about the birth of each and every one of us! In silhouette, the baby is bracing, mouth open, ready to take on the world.

This photograph was made *without* using a camera. Instead, Len placed a well-behaved baby onto a sheet of light-sensitive photographic paper which was then exposed to light. (This is what's called a 'photogram'.) A few other items were also placed alongside the infant: a ring, a twist of wire and a small figure-pendant which looks like it could be either a wooden Māori doll or a jelly baby (a sweet once popular with children). When I look at Len's photogram, I can almost hear the whoop of joy, the loud exclamation of someone who has only just, a moment ago, joined the human race.

- **Len Lye** (born in Christchurch, 1901, died 1980), *Child with Figurine*, 1947

- **Len Lye,** stills from *Rainbow Dance*, 1936. Throughout his career as a kinetic sculptor, film-maker, photographer and poet, Len Lye sought to capture the boundless energy and joy of being alive. His film *Rainbow Dance* is an experiment in colour and movement. Incorporating hand-colouring and ingenious visual effects, Len Lye's movies often look like still photographs which have come to life.

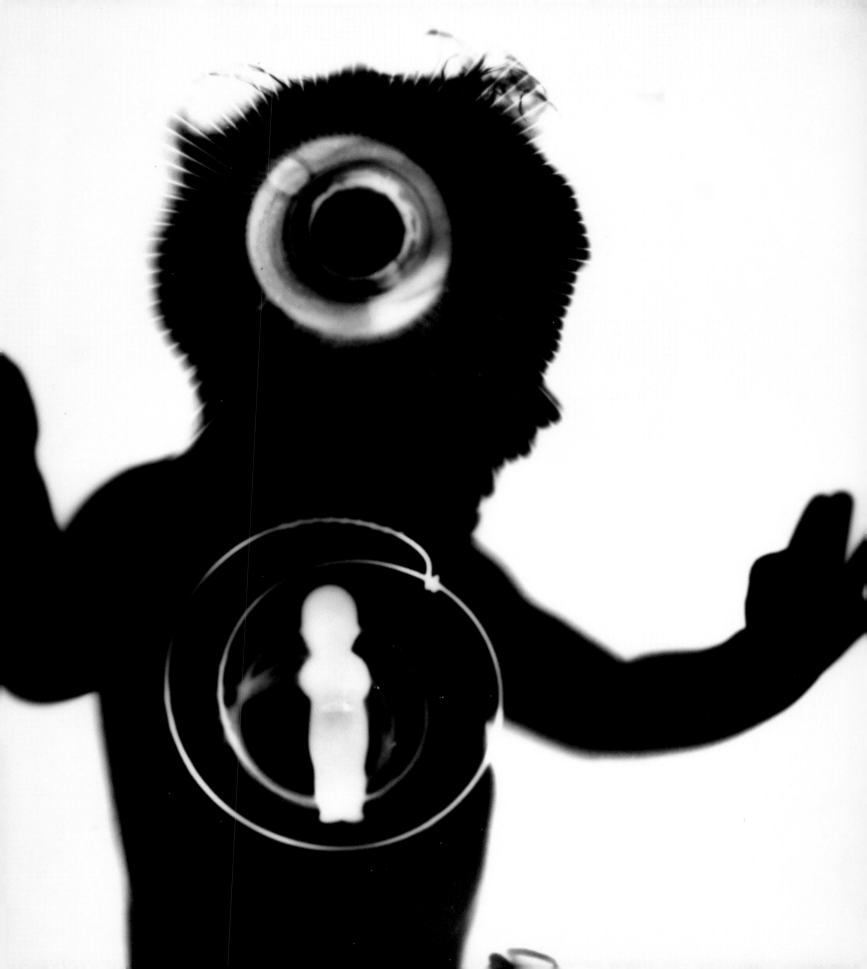

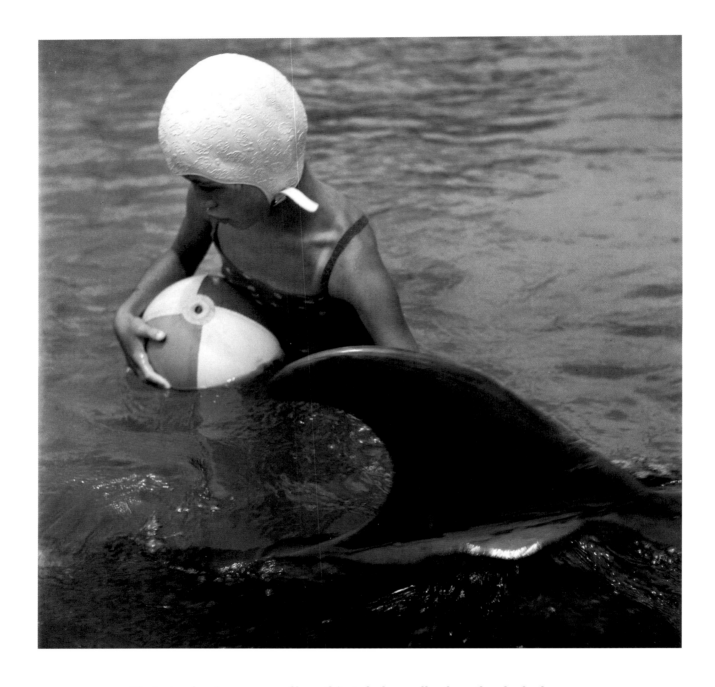

Photographs give a sense of how things feel as well as how they look: the coolness of water, the sun on your shoulders, a bathing-cap (a little too tight) on your head, and the shining body of a dolphin swimming past . . .

• **Eric Lee-Johnson** (born in Fiji, 1908, died 1993),
 Opo, the Hokianga Dolphin (#16), 1955

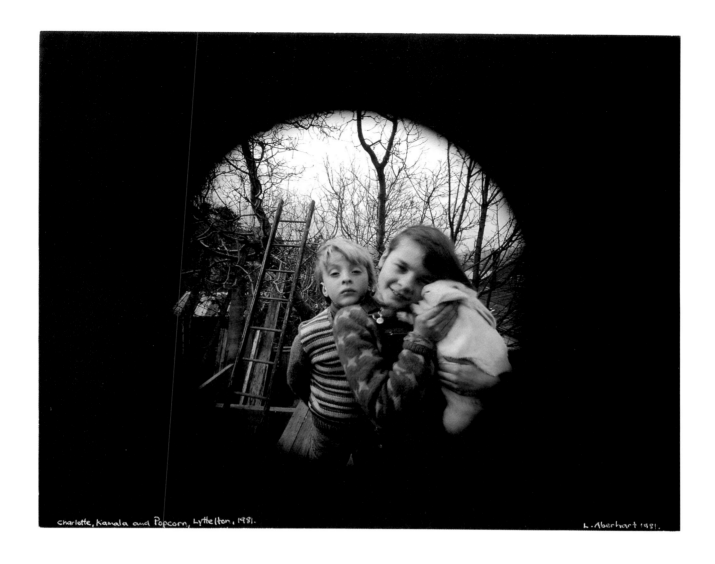

Charlotte, Kamala and Popcorn, Lyttelton, 1981.

L. Aberhart 1981.

- **Laurence Aberhart** (born in Nelson, 1949), *Charlotte, Kamala and Popcorn, Lyttelton, 1981*. Laurence Aberhart's photograph of his two daughters and their pet is like something viewed through a telescope. What do you see here? A girl holds a rabbit; her sister looks like she is plotting something. They are up in a treehouse (hence the ladder and the branches). You can tell it is winter because the trees are without leaves and the children are in jumpers. And the rabbit makes me wonder if the photograph was inspired by Lewis Carroll's *Alice's Adventures in Wonderland*, in which the main character is led by a white rabbit down a tunnel into a strange new world. Maybe the lens of the camera is the opening of a tunnel and the interior of the camera is the place where such wonders and unexpected things are gathered?

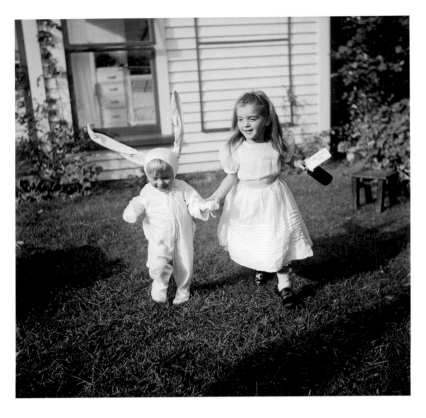

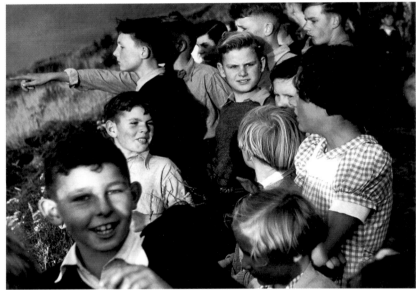

Photographs hint at life stories and events that extend through time – before and after the instant when the photograph was taken. The camera captures moments but it can also contain a very long time.

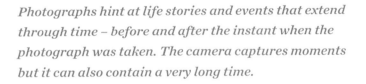

• **Gary Blackman** (born in Dunedin, 1928), *Children watching a gorse fire*, North East Valley, Dunedin, 1952. Here we have a moment in history: a fire on the edge of town. However, instead of photographing the action – the smoke and flames – Gary Blackman has turned his camera towards the children watching the blaze. One of the first things you might notice is the different textures of their clothes – wool and cloth – and their haircuts. Then you notice the variety of their responses to the fire which is blazing off to the left of the photographic frame. We detect excitement, worry (the girl in the checkered blouse), cool detachment; one boy points with his finger, another looks away; yet another is laughing at the adventure. Is the fire out of control or are they just watching an ordinary burn-off of scrub? Probably no one remembers this particular fire today. But, because of this photograph, the group of young, captivated people is certainly remembered.

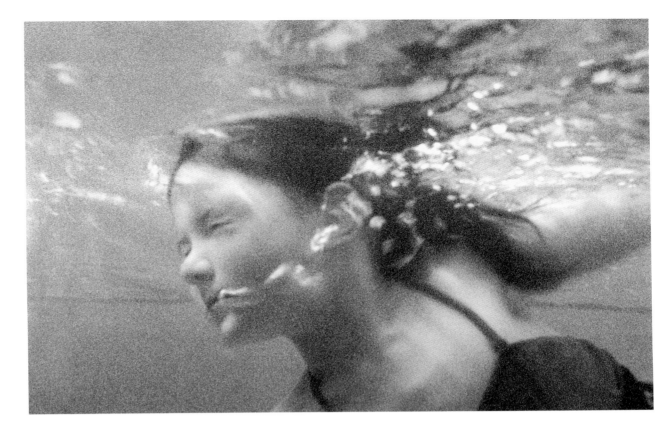

For some years, I taught creative writing. I kept a print of Dean Johansson's photo *Swim* hanging on the classroom wall. Photographs can be a great catalyst for writing poems or stories. I was continually amazed at how young people would respond to this image. Was she swimming confidently or sinking? Was the swimmer trying to get away, or was she trying to get somewhere? What was she thinking?

- **Dean Johansson** (born in Wellington, 1961), *Swim,* 1989
- **Max Oettli** (born in Switzerland, 1947, arrived in New Zealand 1957), *Department Store*, Auckland, 1972

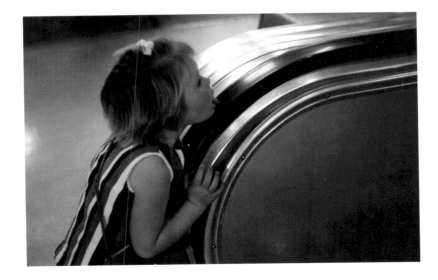

The strange box walking the earth is always happening upon odd and unexpected things. Sometimes it seems as if the camera is a magnet which attracts unusual things or characters or events. A man does a headstand on top of a power pole; a girl pokes her tongue out then licks the moving handrail of an escalator. You would never have dreamt or imagined such things, but the camera finds its way to them, and it photographs them.

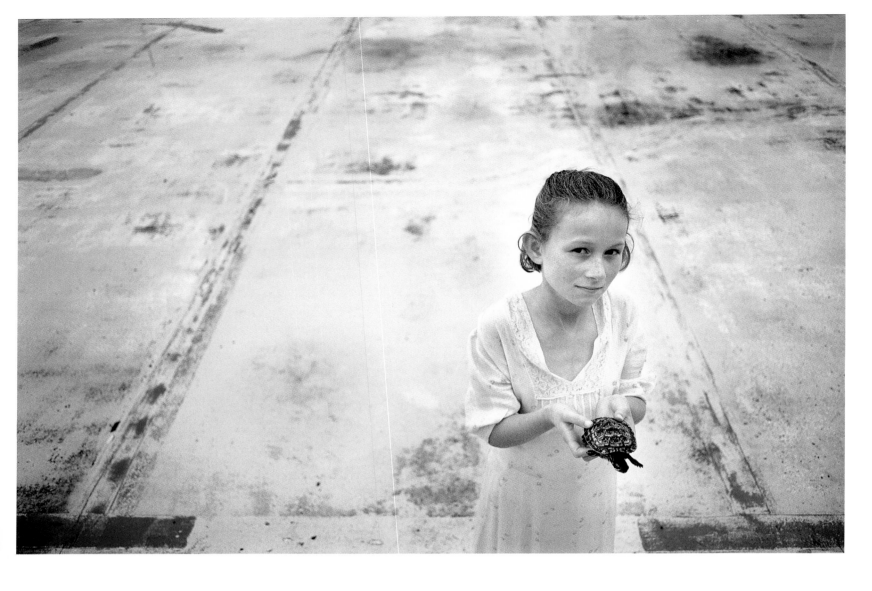

• **Deborah Smith,** *Alice and Walter, Marine Parade,* 2000. It looks as if Alice is standing in an empty swimming pool. Maybe she had to drain the pool of water so that she could recover her lost turtle? Photographs, as we've seen already, tell bits of stories and they leave us to make up the rest. In the fifteen years since this photo was taken, Alice has grown up. Instead of carrying a turtle, she now works as a waitress in Auckland and spends her evenings carrying trays of food and drinks. (During the day she is studying art at university.) Time passes. The empty swimming pool in the photograph might not even exist any more. However – on a brighter note – turtles, like photographs, are renowned for their very long lives. Walter is almost certainly still around and probably hasn't changed as much as Alice has.

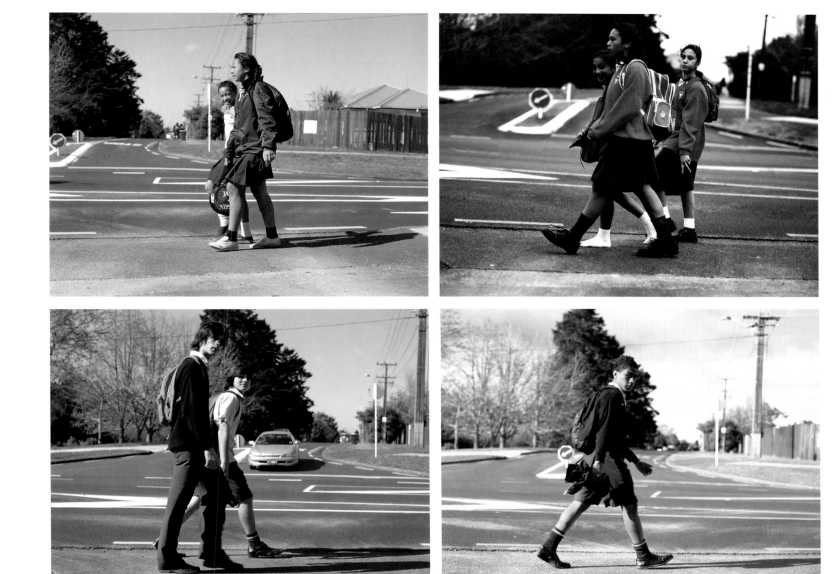

- **Edith Amituanai** (born 1980), from 'The End of My Driveway' series, 2011–2012.

 The end of the driveway is where the rest of the world begins. Edith Amituanai's photo essay, from which these images are taken, focuses on the street in front of where she lives. The photographs portray a very ordinary stretch of footpath, a busy street, a blue road sign with an arrow and a few power poles. There are no photographic tricks – the lighting is bright and the view is straight down the driveway. And here come the local young people: striding or dawdling, walking in formation or straggling. Their body language tells us a lot about them. Some of these secondary students clutch bottles of soft drink; others wear hand-me-down uniforms which are much too big for them. Apart from a few sideways glances towards the photographer, they are looking straight ahead, to where they are going – these purposeful young citizens of West Auckland.

Photographs can be places where things are invented and stories made up. The space in front of the camera becomes a theatre and the photograph becomes an occasion for playing games, putting on faces and dressing up, as well as for being serious.

In Anne Noble's photo essay 'Ruby's Room', we don't see anything of her daughter Ruby's actual bedroom, or any other room for that matter. Pretty much all we see in this series of portraits is the girl's mouth. Anne captures Ruby's moods: loud and crazy one minute, subdued the next.

In one photo she is spitting tacks; then, before you know it, she is blowing kisses. In some photographs things get a little messy and you wonder what on earth she has just eaten. And maybe she's a little cross in the photograph below – a lock of hair is in her mouth.

- **Anne Noble** (born in Whanganui, 1954), *Ruby's Room No. 23*, 2002

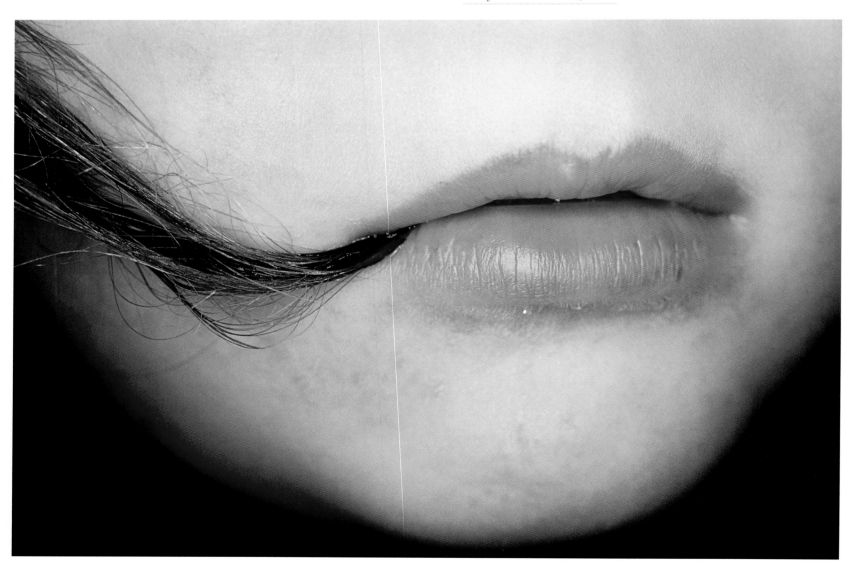

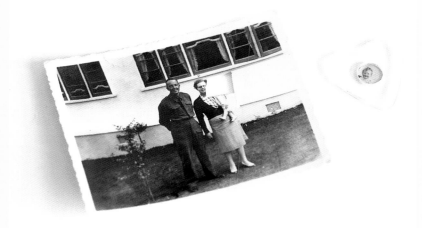 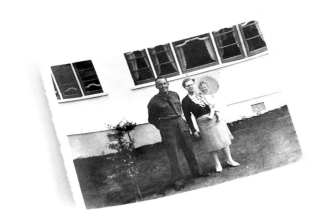

A missing person

My friends Deb and Mark took this photograph of an old family snapshot with a hole cut in it. The couple in the photograph are Deb and Mark's grandparents and the hole in the picture once contained the head of their mother, Lorraine. They kept this photo for years and often wondered why the baby's face had been removed. Was she squealing or pulling a face? You wouldn't cut someone out of a photo just because their eyes were shut. It was a mystery.

Some years later, Deb came across a heart-shaped locket which her grandfather had taken overseas with him during the Second World War. (He's wearing his army uniform in the photo.) The locket, which went everywhere with him during those tough times, contained the missing part of the family photograph, which had been trimmed to fit inside it. Almost seventy years after the war, Deb was able to pop her mother's face back in its place in the family photograph.

• Deborah Smith and Mark Smith, *A family reunion*, c. 1941 and 2014

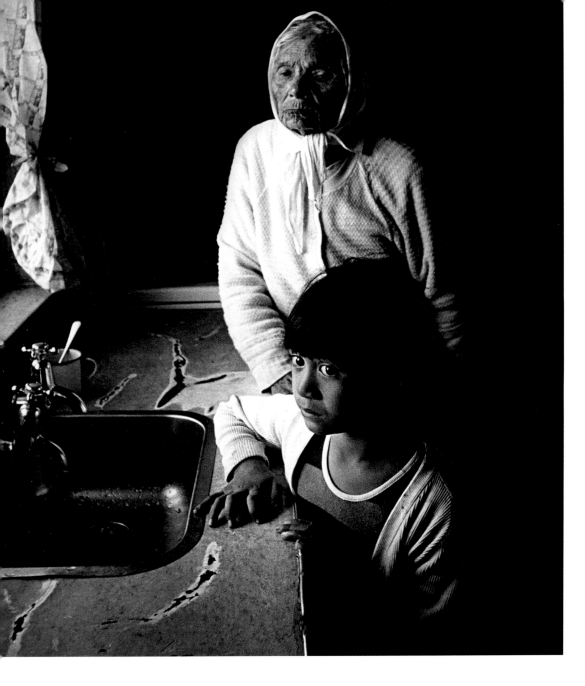

Photographs can say a lot about relationships between people. Within its borders, a photograph might contain a tremor of love or friendship, of family or community relationships. Photographs seldom tell us everything in one glance. And great photographs often take us to places where words can't follow them: a sink, a window, an elderly woman and her great-granddaughter, morning light . . . The photograph brings all those things together in one visual moment.

- **Marti Friedlander,** *Tiraha Cooper and her great-granddaughter, Waikato,* 1970

My ten-year-old niece Holly explained to me the other day that a picture only becomes a 'photograph' when it is printed on a piece of paper or in a book. As long as the picture is inside the camera or on a computer, she says, it's just an *image*. Photographs come later. Most families, from most cultures, keep photographic prints of parents, grandparents and children on mantelpieces, framed on walls or in albums at home. These images, printed in colour or black and white, are one way we remember our ancestors and family members. That is the purpose they serve in Māori meeting houses – wharenui – where old and recent photographs are hung in pride of place.

- Lucien Rizos, *House Interior – Hiruharama, Whanganui River* and *Vintage Photograph Display – Invercargill*, 1979–1982

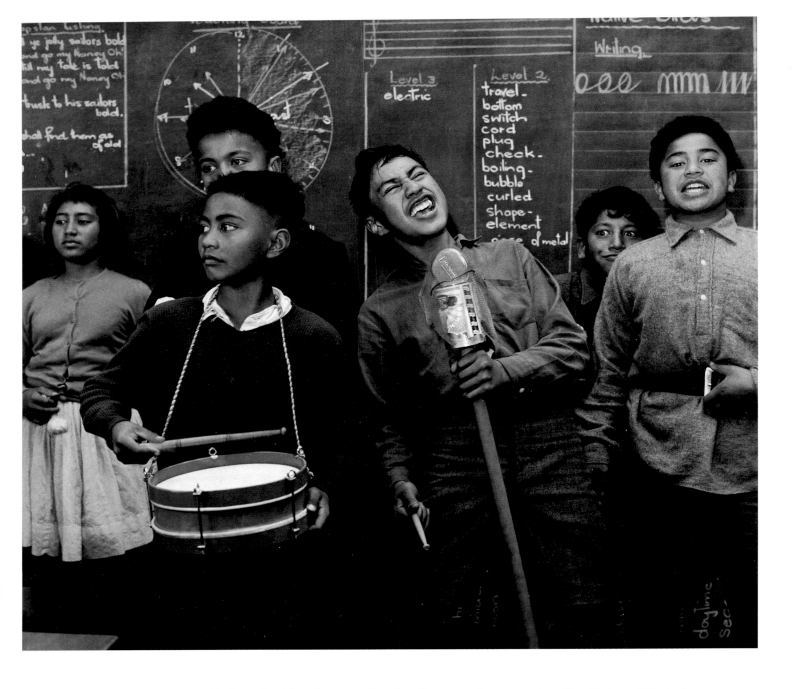

Black-and-white photographs often have a quiet, inward quality. But Ans Westra's 1963 photograph of a classroom is crowded, loud, boisterous and full of energy. Looking at Ans's picture, you can almost hear the boy crooning (maybe he is impersonating Elvis?) and the uncertain beating of the drum. And, in the background, such a lot of *visual noise* – all those words on the blackboard, waiting for someone to pay attention to them.

• **Ans Westra,** *Students performing, Whatatutu primary school, near Wairoa,* 1963

Photo-artists who record things happening in the world around them are sometimes called 'documentary' photographers. Their images offer an impression of society at large, and of groups within that society – from politicians to surfers, from gang members to marching girls.

How people get along with one another, what angers or upsets them – politics, injustice, poverty – and what gives them joy – music, family, community – these are the themes in John Miller's 'documentary' photography. He is especially good at capturing the spirit and character of groups of people – on protest marches or at trade union meetings, in bus shelters and on marae. His photographs are portraits of lives as they are being lived. For decades, he has travelled the land with his camera in a beaten-up carry-bag, and his eyes wide open.

- **John Daley** (born 1946, died 2012), *Courtenay Place, Wellington*, 1969
- **John Miller** (born in Auckland, 1950, Ngāpuhi), *Hastings Ratana Band, opposite the Temple*, from the series 'Ratana Pa', 1976

Good photographers sense what might be about to happen. There is guess-work and intuition. They constantly surprise themselves when their negatives have been processed or their image files downloaded onto their computer.

• **Greta Anderson,** *Young couple waiting for the storm,* 2013

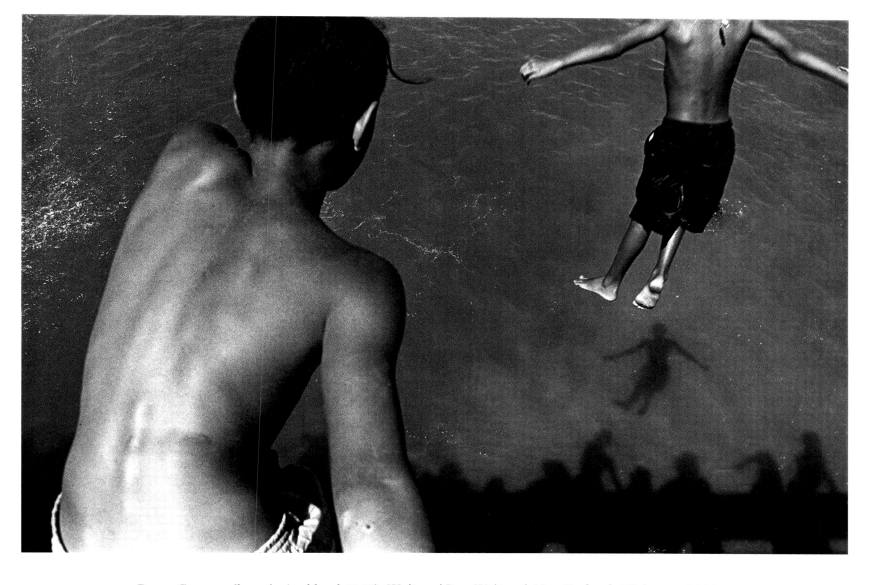

• **Bruce Connew** (born in Auckland, 1949), *Waitangi Day*, Waitangi, New Zealand, 6 February 2000

Photographers emphasise certain objects or figures within the photograph by the way they position them. Sometimes this is done with lots of planning and control. At other times – well, it just happens. In Bruce Connew's photograph of boys jumping off a bridge, the head of the leaping figure disappears out of the top of the picture-frame, which adds to the feeling of the boy falling downwards. There is no way you could pre-plan this image – it is the by-product of a sharp eye, a quick mind and an even quicker shutter-finger. The boy's shadow on the water's surface almost connects with his right foot. To the left, the back of the other figure takes up nearly half of the photograph. We feel the warmth of the sun on the boy's back (and we imagine the coolness of the water into which he too is about to jump). The shadows of other children along the base of the image add to the drama. Like them, we are waiting to see and hear the splash . . .

Hand book

What is it that the hands in Helena Hughes's photograph are saying? She took this photograph of her father wearing his best clothes, but his hands remind us that his work was of a physical, earthy kind. He was an orchardist in Hawke's Bay – his hands speak of pruning and harvesting, and also of years spent in the infantry during World War II. They are evidence of a long, productive life. The suit and tie just don't seem all that important by comparison.

- **Helena Hughes,** *Untitled (Pat Hughes's hands)*, undated

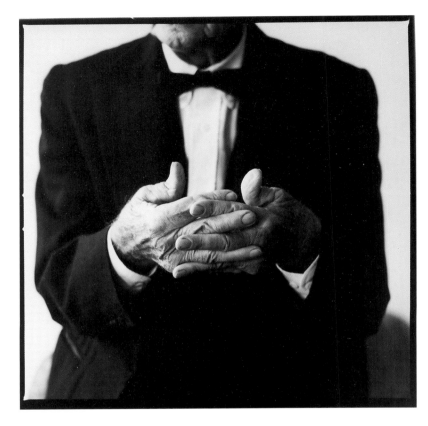

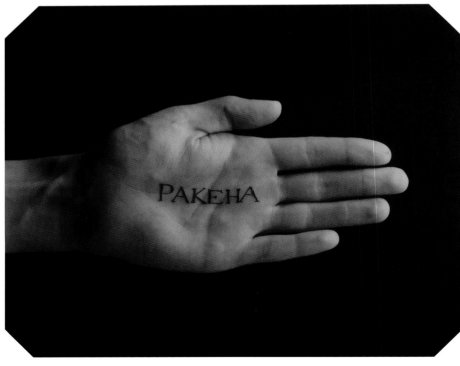

Whereas Helena's picture is about a real-life pair of hands, Ben Cauchi presents the hand as a symbol. With the word PAKEHA written in tattoo-like lettering upon it, the meaning is unclear. Is this a hand extended in friendship or does it want something? Is it signalling stop or go?

- **Ben Cauchi** (born in Auckland, 1974), *Loaded Palm*, 2002

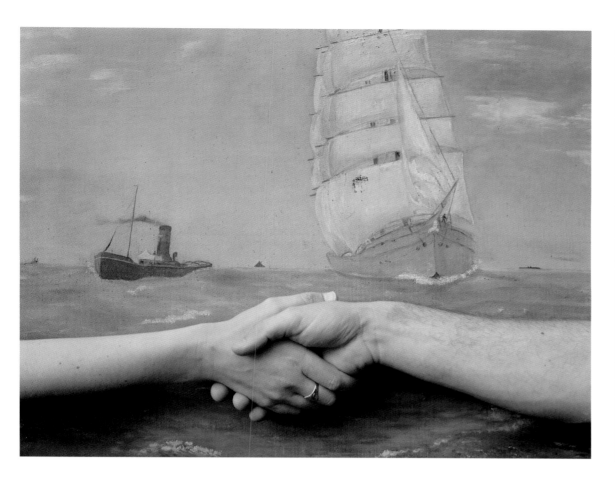 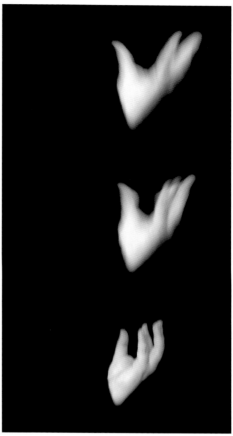

In Marie Shannon's *Across the Water*, we don't get much of a sense of who the hands belong to. Historically, the handshake was often used as a symbol of international friendship and bonds between people. Here Marie places the hands in front of an old painting about ocean travel. She references the past, but the picture seems strangely about the present.

In *Light*, Janet Bayly has photographed a pale hand against a dark backdrop. By altering the camera's focus, the hand at the bottom of the three-part image gradually dissolves into a flame-like shape. Or is a flower opening? Or a symbol of weightlessness and flight?

- **Marie Shannon**, *Across the Water*, 1988
- **Janet Bayly** (born in Tauranga, 1955), *Light*, 2000

Hands can say a lot – about tenderness as well as toughness. Just like the human face, they reveal a lot about a person. (Megan Jenkinson's photograph also reminds us that the human body is a part of nature. With their veins and pores, hands have much in common with leaves.)

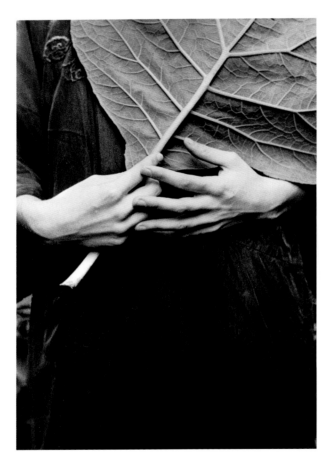

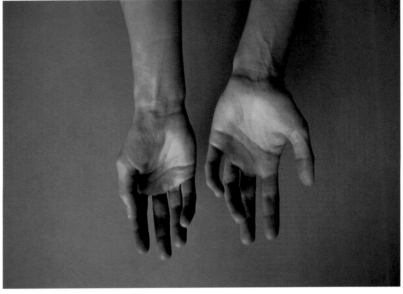

When Frank Hofmann was photographing the pianist Lili Kraus he wanted to highlight the magic of her piano playing – and the hands were the source of that magic. In this portrait, Lili Kraus's face and body are hidden in shadow. It is her hands that the viewers' eyes are drawn to. A circular spotlight dominates the image, hinting at Lili Kraus's life as a concert performer – in the limelight – but we also sense a hidden, private person too. Most of the time, a photographer casts light upon their subject, but here it is the wall behind that is lit. There are lots of rules to photography but, as is the case with all art forms, rules are there to be broken.

- **Megan Jenkinson**, *Untitled*, 1978 (above left)
- **Peter Peryer**, *Julianne's Hands*, c. 2006 (above right)
- **Frank Hofmann**, *Portrait of a pianist (Lili Kraus)*, 1947

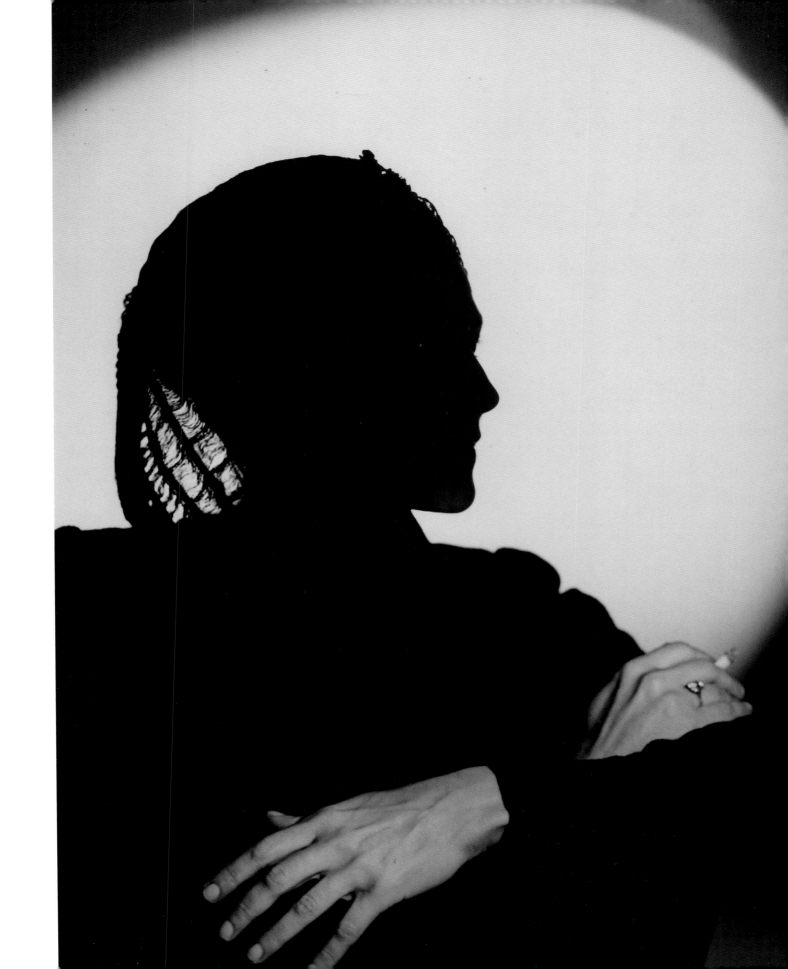

The mysterious hand of Gonville

A few years ago I was walking through the Whanganui suburb of Gonville when I came across an abandoned public swimming baths. Peering over the front fence, I was amazed to see a giant hand in the centre of the empty concrete pool. If I was a photographer (or if I had the good sense to carry a camera with me) this would have made a great photograph. A few days later, the hand was gone.

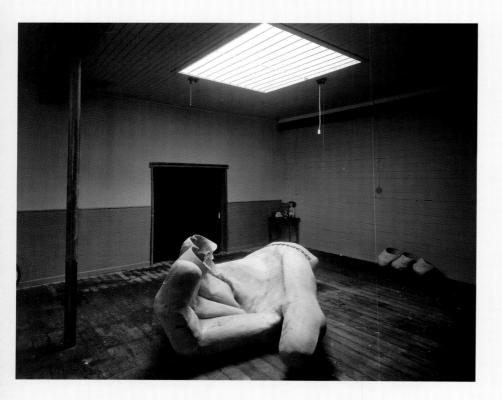

Some months later I came across one of Andrew Ross's Whanganui photographs and there it was: my giant hand! Only this time it was in a shadowy old building which is now a live music venue called The Mutton Club.

Andrew Ross's photo is a study in brightness. Look at the way the hand catches the light that comes through the skylight – it is like a giant baseball glove. Andrew delights in the many different shades of grey that black-and-white photography allows (and the brown, blue or silver tones that different chemicals and papers bring to the final prints). He relishes the capacity of black-and-white photography to register the facts of a scene and also to record tricks of shadow and light.

Much later, I discovered the giant hand had begun its life high above a roadside, holding on to a giant cellphone or the remote control for an electric garage door. From what I hear, the giant hand continues to move, mysteriously (probably by night), around the town of Whanganui. And it seems to me that the job of photo-artists is to follow these strange, remarkable things around and to record them . . .

• **Andrew Ross** (born in Masterton, 1966), *The Mutton Club, Taupo Quay, Whanganui, 4/8/2009*

Face book

A few years back, I was driving around the East Cape with my Samoan writer-friend Sia Figiel. While posing for pretend-wedding photos outside the very scenic church at Te Kaha, we discussed how, in some cultures, people are reluctant to have their photos taken, because they believe the camera might steal their souls. I asked Sia if, traditionally, Samoans were suspicious of being photographed. 'Traditionally, Greg,' she replied, very solemnly, 'we did not have cameras.' And then she shrieked with laughter and doffed her gangster-hat and went back to the car.

A photograph can tell us many things about a person, whether they want it to or not. Portraiture has always been a hugely important factor in photography's popularity. As well as photos of family members and loved ones, there are passport pics, school portraits, celebrity portraits, police photos (sometimes called 'mug-shots') . . . Portraits can vary from informal snaps – including the 'selfies' we talked about earlier – to some very formal and staged productions.

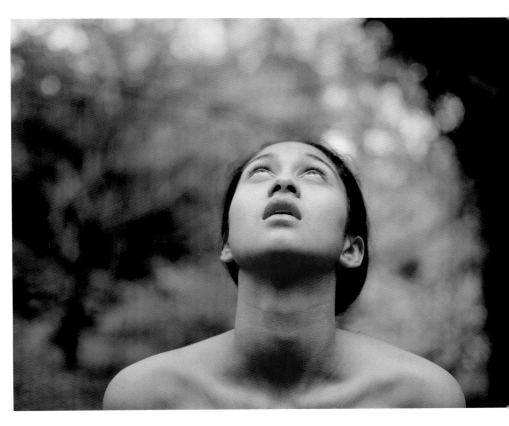

• **Ngahuia Harrison** (born in Whangarei, 1988, Ngāti Wai), *Elizabeth*, 2011

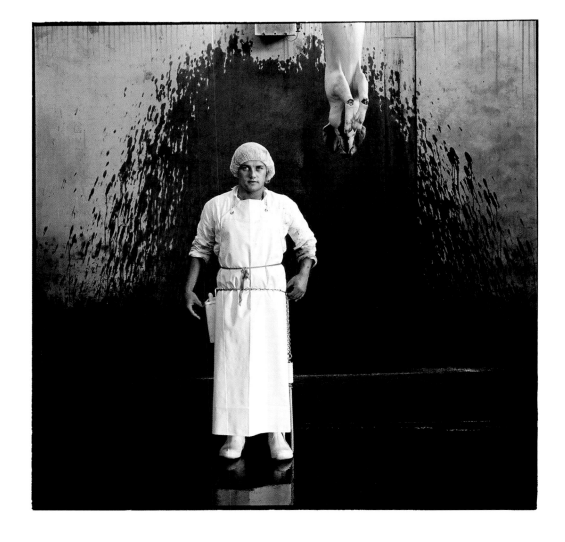

- **Glenn Busch** (born 1948), *Ronny Lewis, labourer, abattoir pig chain, Christchurch 1982*, from the series 'Working men'

One of New Zealand's greatest portrait photographers, Glenn Busch focuses his lens on ordinary people. His celebrated series 'Working men' depicts workers in often harsh industrial environments. His portrait *Ronny Lewis, labourer* captures the resilience and work-ethic of the young freezing worker. Using a medium-format camera capable of capturing immense detail and subtle light effects, Busch placed his subject centre-frame and facing the camera. Portraits like this acknowledge the nobility as well as the personality of his subjects.

Eric Lee-Johnson's self-portrait (on facing page) is a dream-like evocation of the photographer and the world of light and dark he inhabits. The image was recorded on a special 'infra red' negative which is often used for photographing at night. The process gives this daytime scene an ultra-real intensity. Eric placed himself in the midst of the natural world, which he felt so connected to and inspired by.

- Eric Lee-Johnson, *Self Portrait in Infra Red, Waimamaku, Northland,* 1958

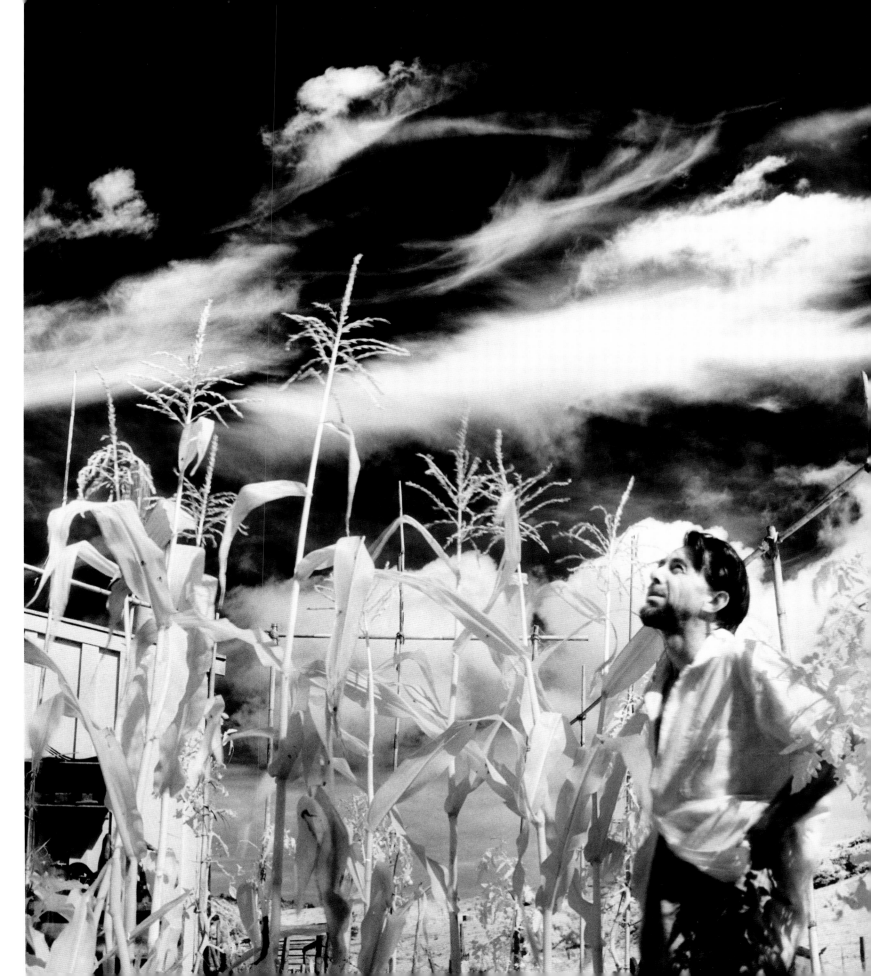

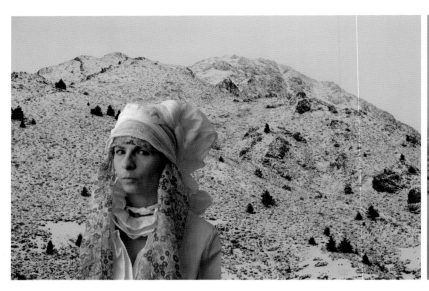 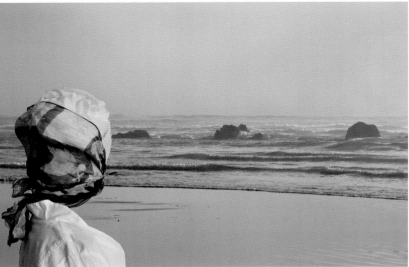

- **Edwards + Johann** (Victoria Edwards born in Auckland, 1948, and
 Ina Johann born in Germany, 1968), *Looking at – The view*, 2009, diptych,
 pigment inks on Hahnemühle photo rag. Are these photographs by two
 artists known as 'Edwards + Johann' about history or fantasy? Are the
 two women trying to explain to us who they are, or are they both role-
 playing? Their costumes share the same icy colours as the landscapes
 behind. Is this a cool, clear day on an unfamiliar planet – or are these just
 snaps of New Zealand locations made stranger by the costumed figures
 that inhabit them? The traditional purpose of portraits was to record
 the way people looked and to capture their character – but these days
 portraiture is just as likely to conceal or obscure their true nature.

- **Yvonne Todd** (born in Auckland, 1973), *Chelsea*, 2000. In Yvonne Todd's *Chelsea*, the girl-subject is only one third of the 'portrait'. Are the mushrooms and the guinea pig here because Chelsea likes them – or relates to them? Maybe she owns them, or dreams about them – or perhaps she is terrified of them? In portraits, surrounding objects or the setting often tell you something about the central character. Whatever the reason for the guinea pig and the fungi, those things are an important part of this portrait-in-three-parts of a young girl.

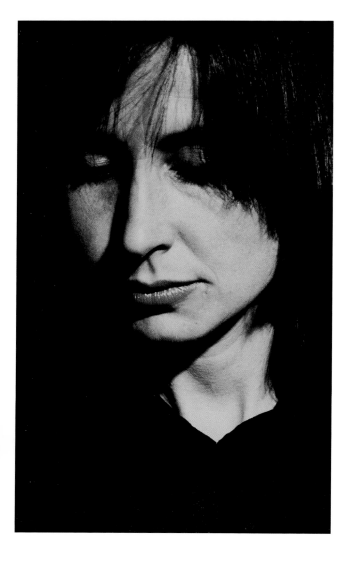

Photographic portraits can be many things. They can be quiet or loud, inward-looking or bursting with energy; they can capture the personality of their subject or they can head off in another direction entirely. Some are posed with great care; others are taken on the spur of the moment. Looking at the photographs on these two pages, which ones feel the most relaxed or, on the other hand, the most controlled? What do they tell you about their subjects? All of the people in these photographs are well-known New Zealand artists. Some look towards the camera while others look down or into the distance. Some are photographed close up, others from further away; some are brightly lit, others in shadow – how do these decisions affect the mood of the photographs?

- **Adrienne Martyn** (born in Wellington, 1950), *Joanna Paul*, 1983
- **Mark Adams** (born in Christchurch, 1949), *Portrait of Tony Fomison at Tai Tapu, Banks Peninsula*, 1972

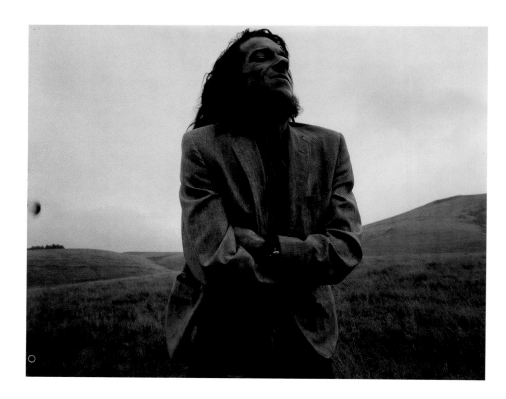

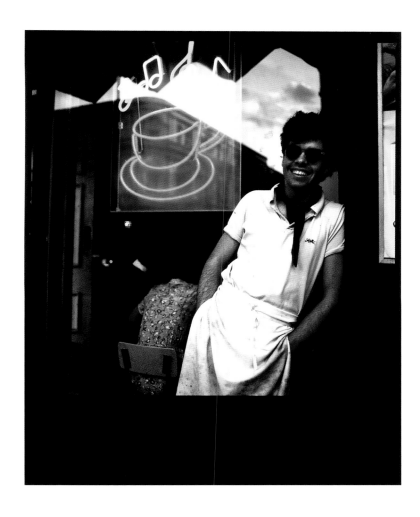

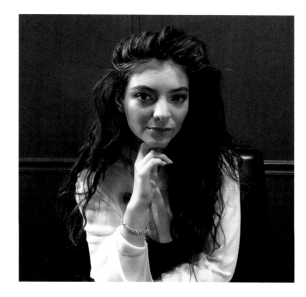

- **Peter Hannken** (born in Auckland, 1958), *John and his Diner*, 1982
- **Sonja Yelich** (born in Auckland, 1965), *Portrait of Ella*, 2014

Peter Hannken's photo of artist John Reynolds started off as an informal snap but, thirty years later, tells us much about Auckland in the early 1980s. There were hardly any cafés in New Zealand at the time and a cup of real espresso coffee was a rare thing. With a neon sign he designed himself glowing behind him, the pioneering owner of John's Diner was young and carefree – although very hard-working – and the sky (reflected in the window behind him) was the limit.

Photographers snap singer/songwriter Ella Yelich-O'Connor every time she performs – as Lorde – or is seen in public. But their photographs seldom say much about who she really is. Her poet/photographer mother Sonja Yelich took this photograph of her after a performance at a famous country music venue, the Grand Ole Opry, in Nashville, USA. 'You can see pure elation in her eyes,' Sonja says. 'I always try and take a photograph after a show. There's a kind of twilight going on when the adrenaline and euphoria are still in her – but fading. It's a kind of "state".'

According to the American writer Gertrude Stein, in photographs of great writers the mouth is always tightly shut. I suspect there isn't much truth in that statement, but it's an interesting idea to put alongside photo-portraits of creative persons (or anyone for that matter).

In my twenties, I learnt a lot about photography while travelling the country with Robert Cross. We were working together on a book about New Zealand writers, *Moments of Invention*. All the branches, leaves and buds in the photograph below remind me of the many-coloured wigs children's author Margaret Mahy used to wear when performing in schools. This photograph, which I have lived with for years, captures a number of wordless conversations – between a woman and her beloved cat (which used to sleep on her photocopier), between two trees in her garden, and between the world of Margaret Mahy and our world.

• **Robert Cross** (born in Stratford, 1955), *Margaret Mahy*, 1987

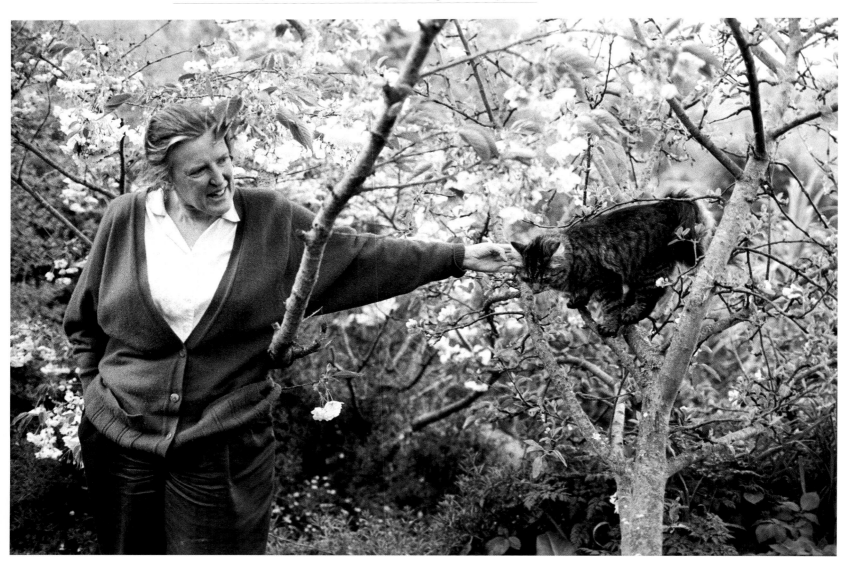

A strange box walks this earth. Or it bides its time, standing on three robust legs. At other times it might be moved around by car or aeroplane. Sometimes it dangles around the neck of someone walking down a street. It follows people around. Sometimes people see the camera coming and they hide, or else they smile, or pull a face, or put on a show.

• **Layla Rudneva-Mackay** (born 1975), *Yellow Curtain*, 2008

Dream machine

Some photographers like to work in studios where they can control many of the things that are so changeable in the world outside. Inside a studio, you don't have to worry about wind, rain, clouds, too much sunlight, intrusive passers-by or stray dogs. You aren't so bothered by the time of day, and you can work on into the night, as long as the models aren't too exhausted by the heat and bright lights.

Photo-artists can create imaginary worlds or strange environments in their studios. Paul Johns constructed a wall-frame and door as part of the backdrop for this puzzling reflection on 'a perfect childhood'. While photographs often just have descriptive titles, sometimes, as is the case here, the title opens up new ways of seeing and understanding an image.

• **Paul Johns** (born 1951), *A Perfect Childhood*, 2002

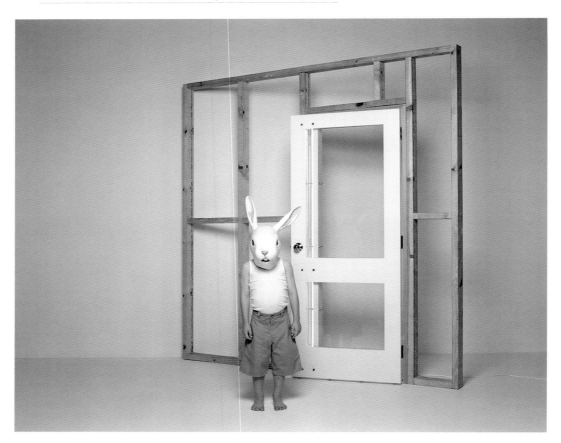

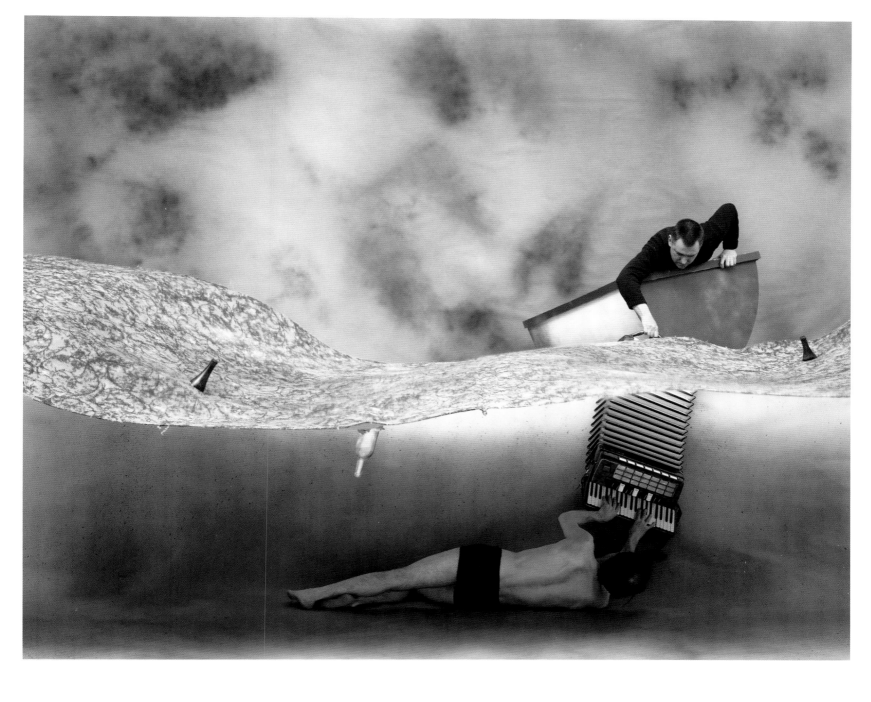

- **Boyd Webb** (born 1947), *LUNG II 1983*. These days photographers can get up to a lot of tricks by using special effects, but Boyd Webb was making very unlikely, fantastical scenes more than three decades ago – in the days before advanced digital technology. He hired actors, carpenters, make-up artists and set-designers to construct dream-like settings in which his characters went about their strange business. Are Boyd's images funny or sinister or deeply serious? Is the photograph, *LUNG II*, a riddle, or a puzzle for us to unravel? What is he trying to tell us?

79

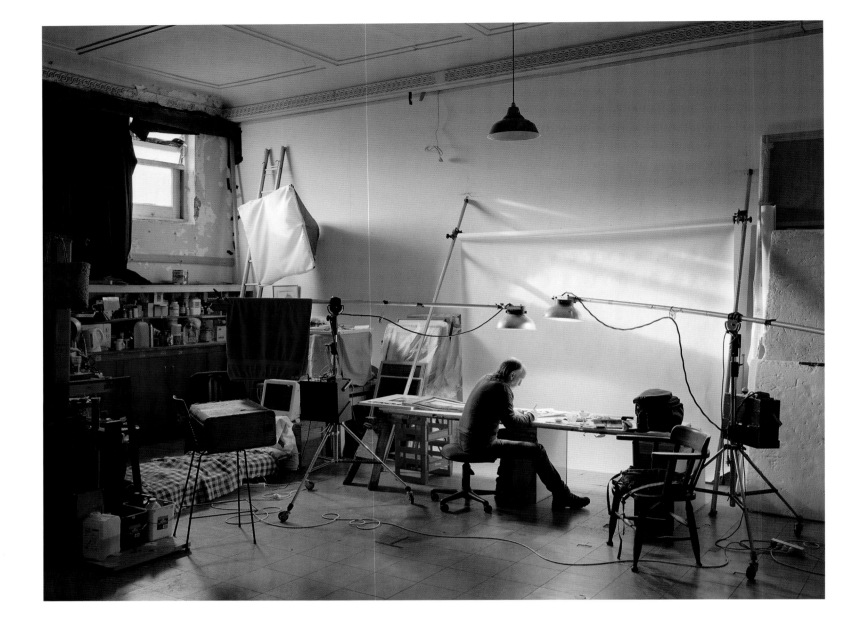

Studio environments can resemble movie sets, with assistants bustling about, and a vast array of lights and camera equipment, not to mention drop-sheets, props and other paraphernalia.

Whereas the studios of earlier photographers such as Clifton Firth would have included a darkroom, where negatives could be developed and prints made, these days studios are more likely to contain computer screens, hard-drives and ink-jet printers.

I once spent a day in the studio of my friend Helena Hughes. A dairy company had commissioned her to take a photograph of a glass of milk. I can't remember the exact details. The cavernous studio in Wellington was busy with lights on stands,

- **Chris Corson-Scott** (born in Auckland, 1985), *Mark Adams Retouching Photographs at Studio La Gonda*, 2013

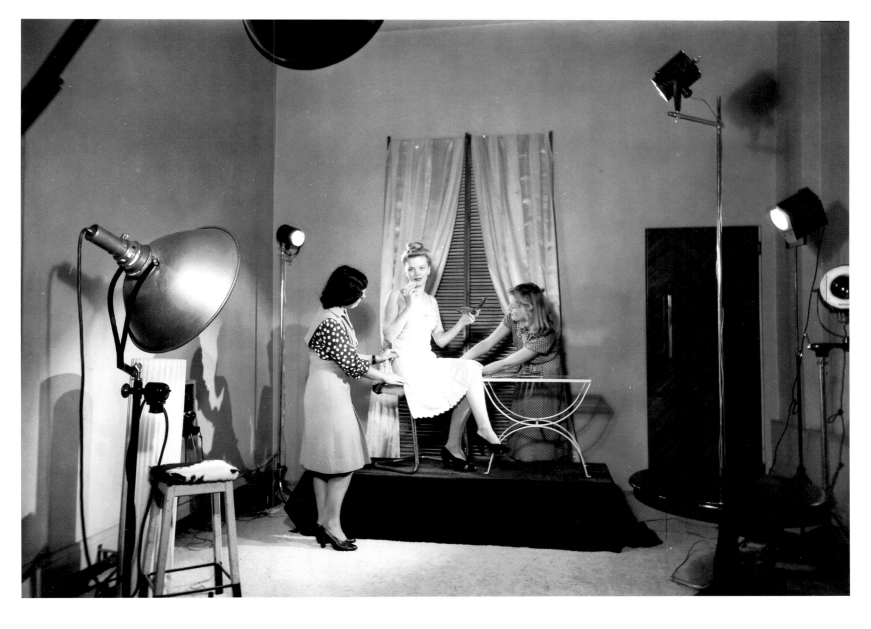

reflector-panels and large black curtains. Upon a small table at the end of the studio sat a solitary glass of chilled milk.

Photographing even a simple object can quickly become a surprisingly complicated business – and a glass of milk is no exception. You have to work out which way the shadow of the glass should fall, the angle and intensity of the light. You have to fine-tune the whiteness . . . The main purpose of this particular photograph was to make the viewer feel like drinking a real glass of milk. Every hour Helena's assistant had to disappear down the road to buy a fresh litre from the dairy as the heat and brightness from the photographic lights made the milk go off.

- **Clifton Firth** (born in Auckland, 1904, died 1980), *Photograph of the interior of Clifton Firth's studio*, c. 1940s

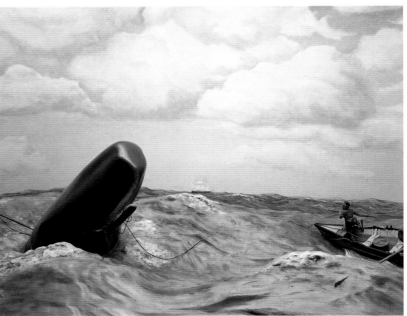

Having travelled all the way to Antarctica and taken many photographs of the actual ice and snow, Anne Noble then spent months going around institutions and aquariums – in New Zealand and overseas – photographing miniature museum-versions of the southern continent. In these dioramas, the grand adventures and massive icebergs of the outside world are shrunk to the size of children's toys.

Another explorer of miniature worlds, Marie Shannon starts from scratch when 'constructing' a photograph. In the early 1990s she made characters from pipe-cleaners and tiny environments out of pieces of paper and cardboard. Marie was married to the artist Julian Dashper (1960–2009). Julian is the stick figure on the telephone at the centre of this photograph. The empty picture frames, imitation wood surfaces and purposefully wonky perspective are the kinds of things Julian Dashper included in his art. Marie's photograph is definitely an affectionate portrait of their shared living and working environment. It might also be her way of saying, 'Get off the phone, Julian!'

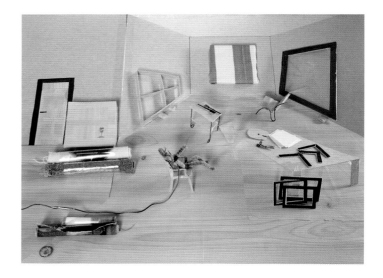

- **Anne Noble,** *The Polar Sea (Antarctica, Seaworld, San Diego, USA),* 2003–2004, and *Whaling, Antarctica (Canterbury Museum),* 2003
- **Marie Shannon,** *Portrait of Julian Dashper,* undated

A mysterious kiss

During the years I was a curator at City Gallery Wellington, I was lucky enough to work on a touring show of photographs by Laurence Aberhart. After the exhibition had completed its run at the Dunedin Public Art Gallery, I was handed a report on the condition of the works. (A condition report is completed whenever an exhibition leaves a venue – it notes if any of the works have been bumped or scratched or – god forbid – lost.)

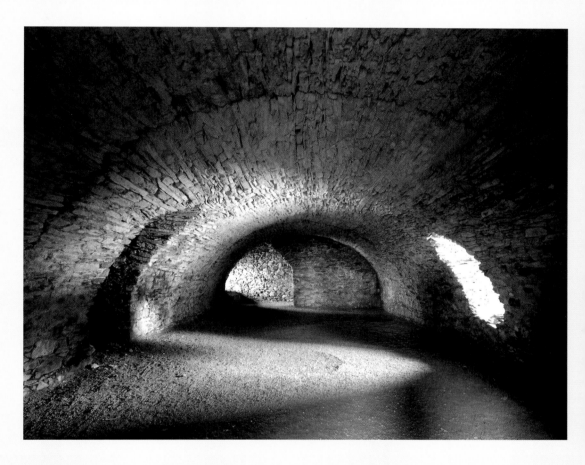

On this occasion, all the framed photographs were in perfect condition – except, in the case of one photograph (a shadowy image of the interior of a tomb), where the report noted there was the imprint of a young woman's lips wham-bang in the middle of the glass. The lipstick was of a medium-red colour and glossy, the report said.

By the time the touring exhibition reached Auckland, its next venue, the glass had been wiped clean – but, to this day, I find myself wondering what it was that made someone kiss this particular image. Was it a mischievous prank, or did they feel a soulful connection with the image? Did they think it was such a great photo they couldn't hold themselves back? Or maybe the young woman was from the place in Wales where the photograph was taken?

- **Laurence Aberhart,** *Interior, Bishop's Palace, St Davids, Pembrokeshire, Dyfed, Wales, 1 November 1994*

Town and country

The world just beyond the window of your home or school or car is alive with photographic possibilities – in the far distance or close up. Or both at once, as is the case with Wayne Barrar's photo of Mt Ngauruhoe and a clump of lava-like rock. (Here, the camera has rendered the volcano and rock identical in size and shape, like twin pyramids.) With its huge variety of landforms, interestingly ramshackle towns and thriving cities, New Zealand might be the best country on earth in which to be a photographer. Whether you are interested in overwhelming mountainscapes, wave patterns, rock formations, street scenes or quirky details from the natural and human-made environment, our country has plenty to say to each of us.

- **Wayne Barrar** (born 1957), *Ngauruhoe and Rock*, 1986

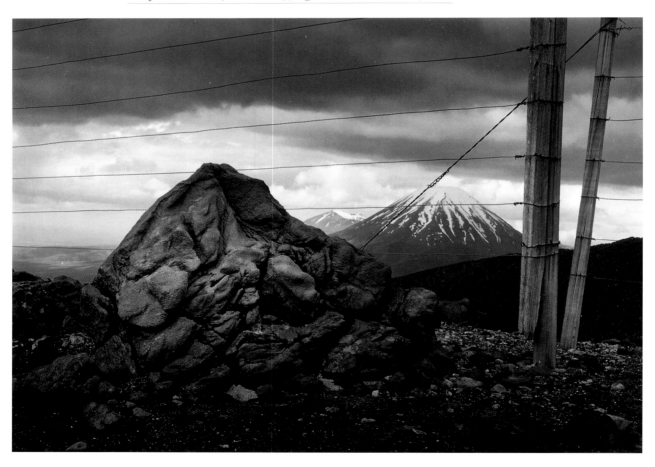

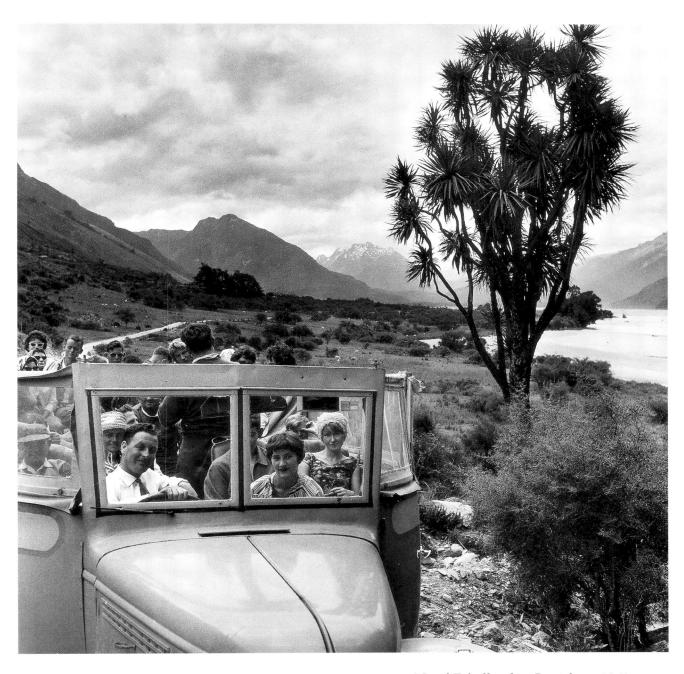

A strange box walks the land, recording the world around it, with its seasons and weather. Paying particular attention to the angle of shadows and the fall of light, the box collects landscapes, street scenes, back-yards and the interiors of houses. It collects the time of day and the time of year . . .

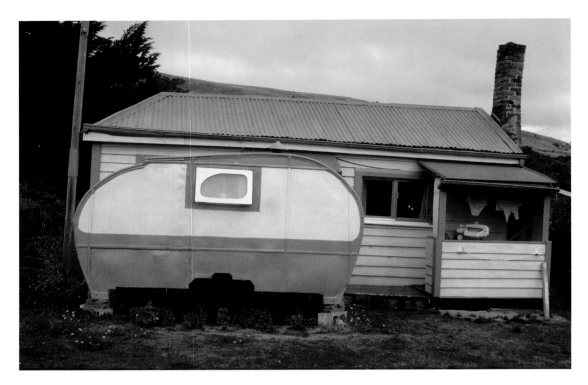

A journey isn't only a landscape, it is also the people you see along the way.

In recent decades many of New Zealand's greatest photographers have taken to the road, travelling the length and breadth of the country, shooting either from the roadside or from a speeding car. Among the country's greatest photo-books is Robin Morrison's *The South Island of New Zealand from the Road*, which was published in 1981. That book shaped how many New Zealanders saw and thought about their country. Robin gave us reason to feel proud of our faded old caravans and ramshackle beach houses, and to acknowledge our own place in this characterful land.

• **Robin Morrison** (born in Auckland, 1944, died 1993), *Pink Caravan, Harwood, Otago Peninsula*, 1979, and *Ben and Balthazar, Fox River, West Coast*, 1979

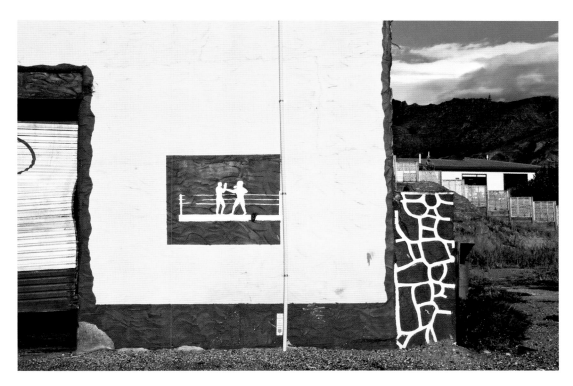

Nothing stays the same. And photography is one way we keep track of change: people grow up; houses are built and demolished; a forest makes way for a road. In 2008, Mary Macpherson photographed the exterior of a boxing club in the small South Island town of Alexandra. Returning two years later the building had been almost completely demolished – all that remained of two figures painted on the front of the building was their lower legs and feet. Where the wall once stood, the blue sky and interesting cloud forms carry on as if nothing has changed.

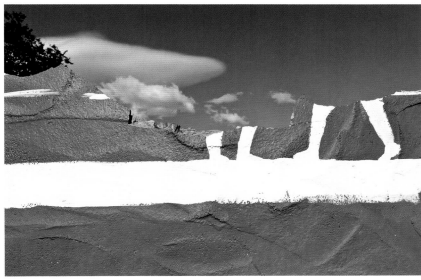

- **Mary Macpherson** (born in 1952), *Alexandra, Central Otago 2008,* and *Alexandra, Central Otago 2010*

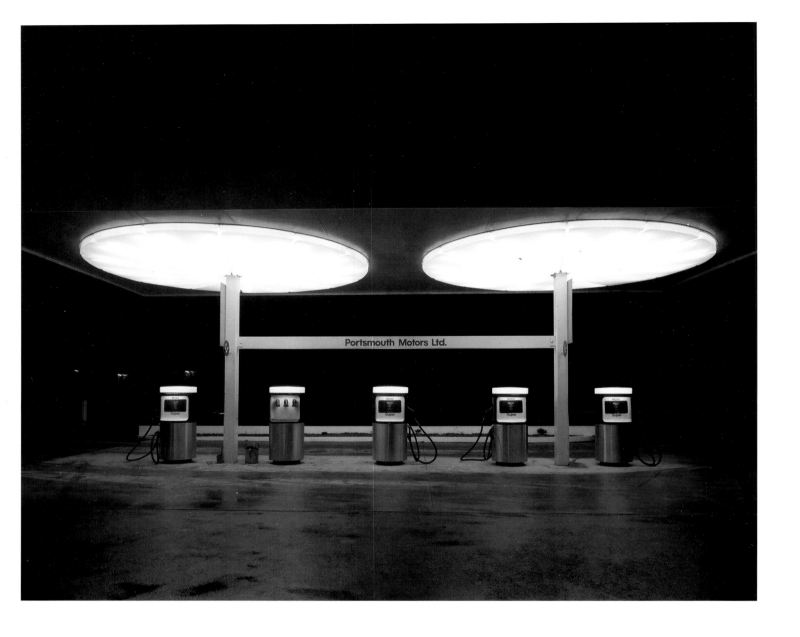

- **Haruhiko Sameshima** (born in Shimizu City, Japan, 1958), *Portsmouth Motors Ltd*, 1980. Driving down even ordinary roads can lead to some surprising opportunities. Haru Sameshima was 22 years old and living not far from Portsmouth Motors Ltd, near Dunedin, when he took this photograph. He had driven past the petrol station all hours of the day and night; he had filled up his car there. Finally, he decided that a night-time shoot was the best idea. With the background swallowed up in darkness, the surreal roof forms came to life. Since then, Haru has continued to work in a similar vein, photographing human-made structures which somehow contain human stories and dreams.

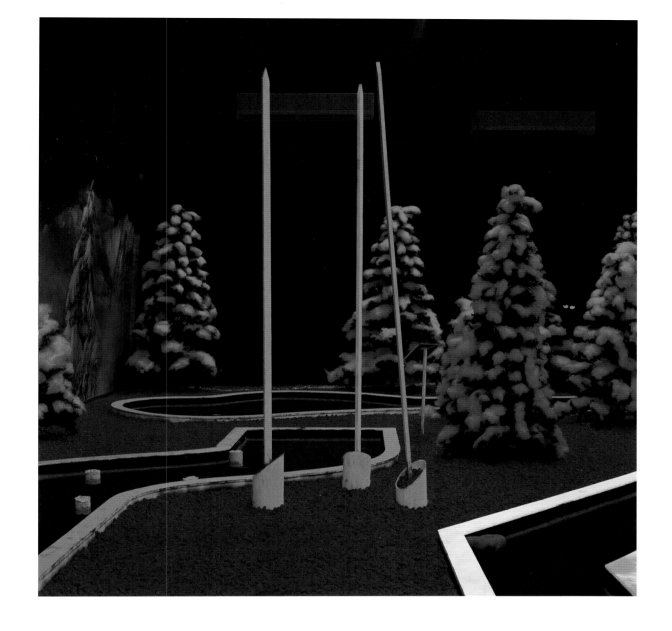

- **Sam Hartnett** (born in Auckland, 1979), *Black Light, Mini Golf,* 2009.
Aucklander Sam Hartnett is also interested in the way humanity sits within
the natural world – particularly in the big city. One day he was driving around
West Auckland when he noticed a roadside sign announcing 'Transylvania
Indoor Blacklight Minigolf Course'. Camera in hand, he went inside. Sam
took a few publicity shots for the minigolf company in return for the oppor-
tunity to photograph their premises for his own purposes. Looking more like
a scene from a science fiction movie or maybe a Christmas pantomime set,
the image captures the strange ultra-violet lighting technology and artificial
environment without using any special photographic effects.

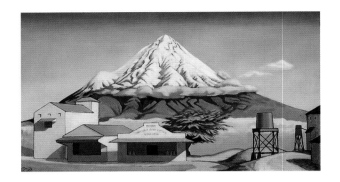

Since the invention of photography, paintings have often been inspired by – or based upon – photographic images. But it's also true that many photographs have been inspired by paintings. This is definitely the case with Christopher Perkins's famous painting *Taranaki* (1931) and the many photos of the North Island mountain that have followed.

In Brian Brake's photograph *Mount Egmont/ Taranaki from Tariki* (1978), Perkins's iconic dairy factory is replaced with another building you often see around New Zealand: the local pub. He includes a railway sign in the foreground, for good measure, and the mid-summer mountain, with hardly any snow, in the background.

- **Christopher Perkins** (born in England, 1891, died 1968), *Taranaki*, 1931, oil on canvas
- **Brian Brake** (born in Wellington, 1927, died 1988), *Mount Egmont/Taranaki from Tariki*, 1978

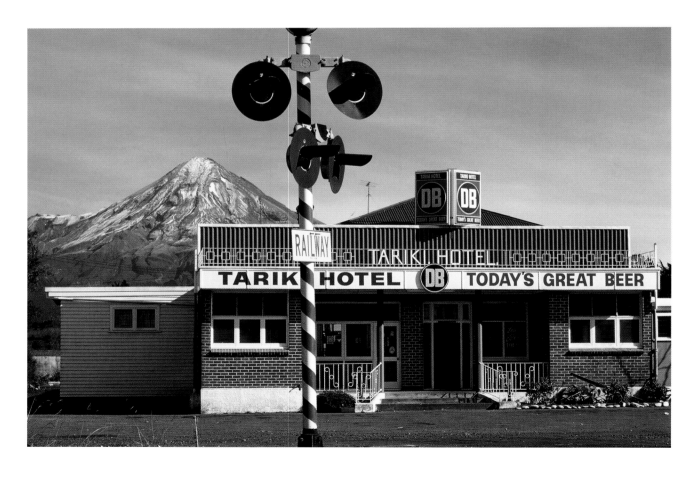

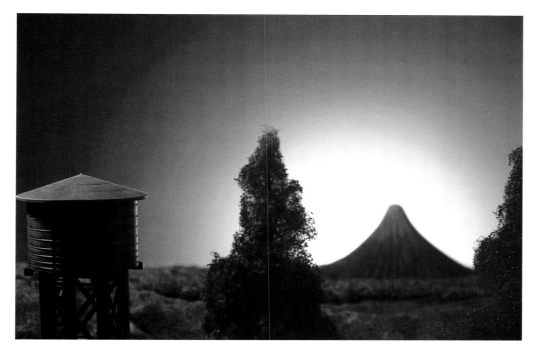

Ronnie van Hout's photograph features a model mountain with a fluffy tree (the kind you would buy in a model railway shop) and, on the left, a water-tower (a miniature version of the one on the right of the Perkins painting). The exaggerated form of the cone-shaped mountain consciously echoes another well-known painting of Mt Taranaki: Charles Heaphy's *Mt Egmont from the Southward* (1840).

In contrast, Laurence Aberhart shifts the viewpoint so the front of the dairy factory leads the viewer's eye diagonally towards the mountain. (In a similar fashion, the road and receding power poles direct our attention towards the distant peak.) The shining brand-new dairy factory which Perkins painted in 1931 has now, it appears, been abandoned – windows are broken and the paint is flaking off; rocks are piling up out the front. We are reminded that the small-town factories which were so much a part of New Zealand life and identity in the mid-twentieth century were, by the 1970s, being replaced by centralised mega-factories.

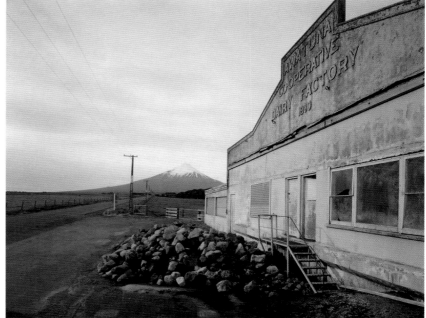

In these three photographs, elements in the foreground are in a dramatic relationship with the unchanging mountain-shape behind. There are no people in any of these images but, in their different ways, they all tell us many things about how people live – past and present.

- **Ronnie van Hout** (born in Christchurch, 1962), *Taranaki*, 1992
- **Laurence Aberhart**, *Taranaki from Awatuna, Taranaki, 27 September 2009*

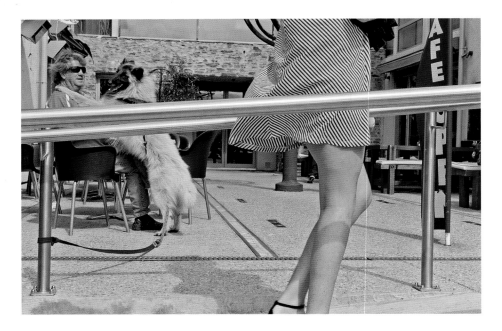

You take a photograph of one thing and you find, later, you have taken a photo of many things. One day in Wanaka, Peter Black was pointing his camera towards a man with a dog when, by chance, a young woman strode past, and he clicked the shutter. It was only later he noticed the wonderful textures and patterns: the girl's stripy dress and freckled legs; the dog's plush fur, the shiny metal railing and clunky wooden furniture, the flapping banner, and the stony architecture and courtyard. Chance and good luck are often important ingredients in the best photographs.

Was it good luck or astute planning that so many horses appear in John Turner's photograph, one of them framed by the girl's arm and the central horse's neck? Turner captures the girl's pride and seriousness, and the pony's contentment. The coming together of human and animal worlds is summed up in the foreground of the photograph, where a bath-tub (no doubt from someone's home) has become a drinking trough in a horse paddock.

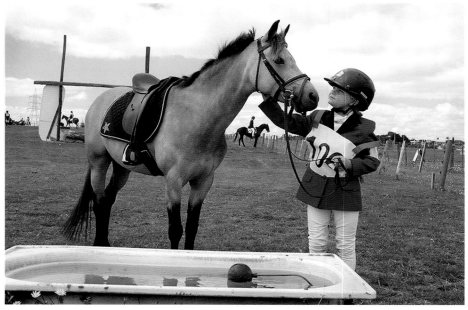

- **Peter Black,** *Wanaka,* 2010
- **John B. Turner** (born in Porirua, 1943), *Te Atatu Pony Club,* 2006

'You can tell a great photograph by whether or not it has a horse in it,' one of my young nieces likes to say.

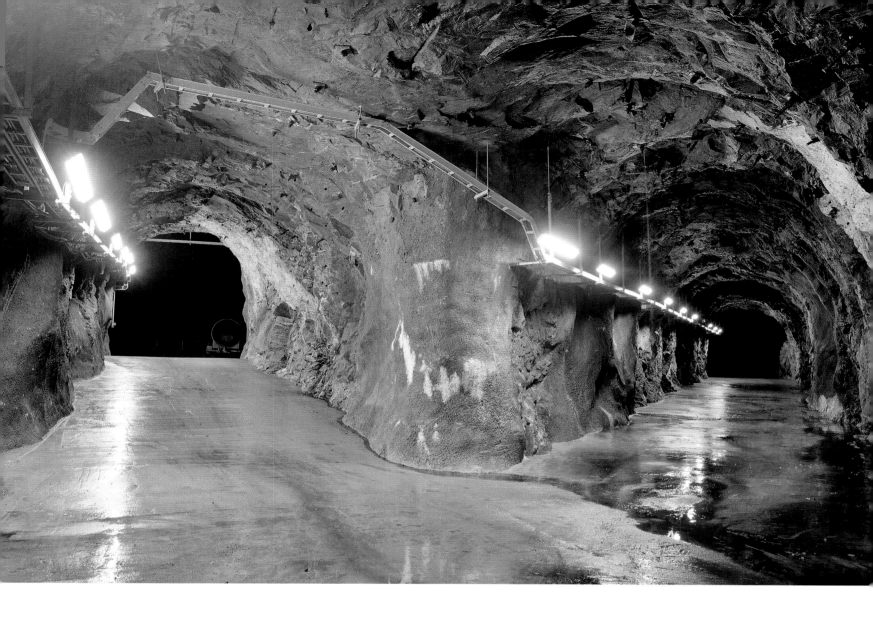

While John B. Turner and Peter Black are both well known for their photographs of roadside scenes, often taken from speeding cars, Wayne Barrar has produced many great photographs of underground roadways, carparks and even dwellings. He makes us face up to the mind-boggling, unsettling fact that there are other worlds beneath the surface of the one upon which we live our ordinary lives.

• **Wayne Barrar**, *Twin tunnels, Manapouri Underground Power Station, New Zealand*, 2005

In the commissioned photographs she takes for fashion designers, Deborah Smith always ensures the personalities of her subjects (or models) are acknowledged. The great theme of her photography is the free-spirited, inventive, unpredictable nature of young women. In this photograph, she plays a game with a fashion magazine, transforming the girl in an advertisement into a Pinocchio-type character simply by adding a mushroom.

• **Deborah Smith,** *Bethells Mushrooms/English Vogue,* 2014

Young women and men in the streets and parks of Wellington are one of Julian Ward's favourite subjects. He snapped these two girls as they were fooling around with their friends on Cuba Street at 3 p.m. on 12 April 2014. 'In situations like this I have a technique of looking slightly past people and using my peripheral vision to watch and wait,' he writes. 'I pre-focused the camera before lifting it. Most often people are not aware they have been photographed even when the camera is only feet away. In this case, the magic moment was the instant they became aware of the camera and I especially like the "haughty look" from the girl on the right.'

• **Julian Ward** (born in Manchester, England, 1948), *Cuba Mall, Wellington,* 2014

94

Inspired by Pacific tivaevae and fabric designs, Nova Paul's photographs and video-works do far more than simply record the world around her. They are like looking through a kaleidoscope. Familiar suburban scenes appear new and filled with energy and exuberance. To make her images, she prints three layers of colour – red, yellow and blue – and the effect is like that of screen-printing or using stencils. Her works are a rhythmical dance – as if the urban environment of Auckland has been set to the beat of some loud, funky Pasifika music.

• **Nova Paul** (born 1973, Tāmaki Makaurau / Auckland, Te Uriroroi and Te Parawhau / Ngāpuhi), from 'Pink and White Terraces', 16-millimetre film, 2006

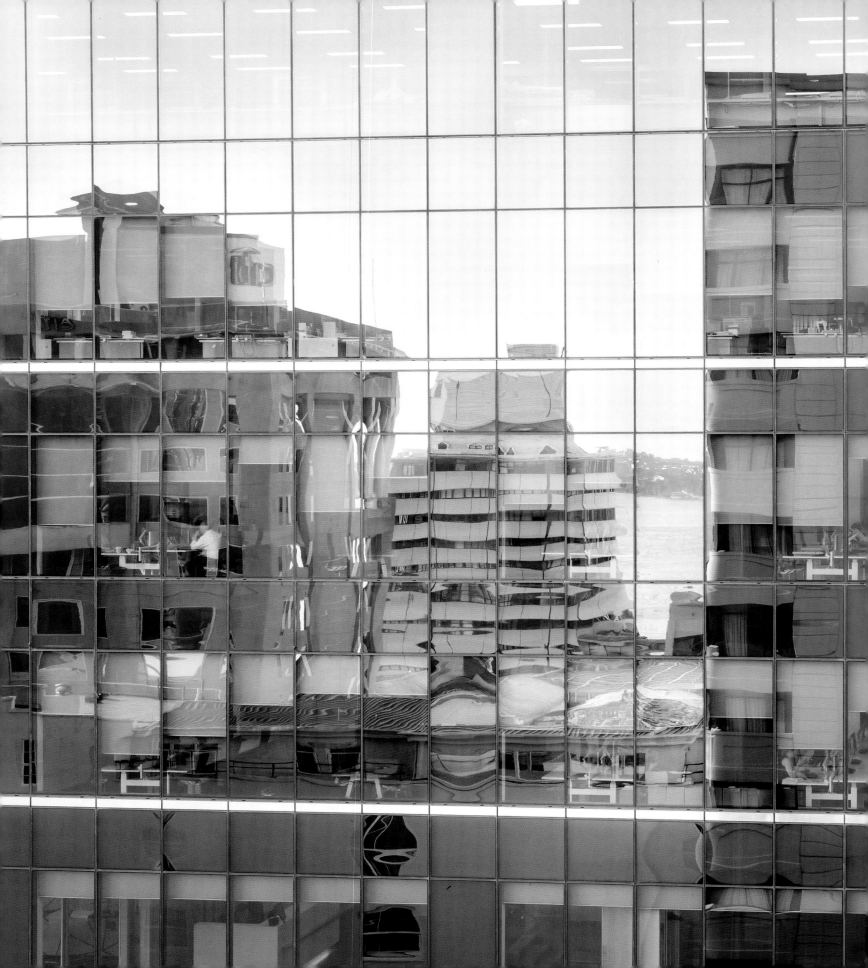

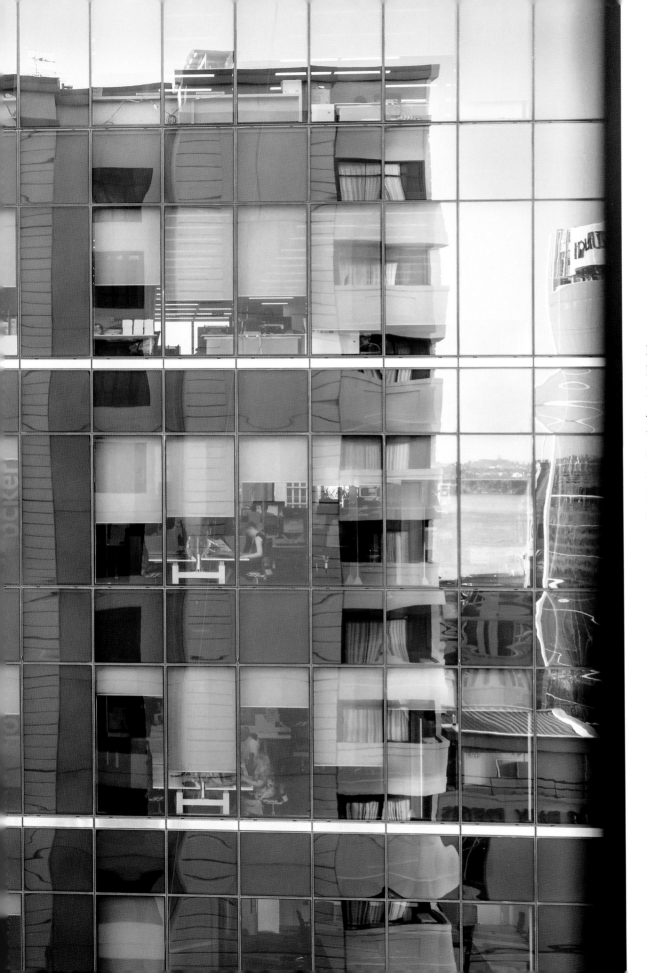

Photographs are all about light and shade. Mary Macpherson's *Desks, Auckland 2014* presents us with many kinds of light: daylight, refracted light, fluorescent lighting (visible inside the rooms), light reflected off the harbour then reflected again, this time off glass panels. The photo also plays with the viewer's sense of space. The flat glass-frontage contains great depths of sky, a receding urban environment and distant sea. Merged into that reflection, we can make out the space inside the tower block, with its interior walls, chairs and, of course, desks.

• Mary Macpherson,
 Desks, Auckland 2014

Theo Schoon's *Silicated sticks* looks like nothing on this earth – the small shells or fossils could be random punctuation marks from an alien alphabet. Just like painting, photography can be a means of exploring abstract shapes, patterns and arrangements. The photograph was taken at Waiotapu in

Rotorua, so the rounded and polished fragments in the work are almost certainly the result of geysers, boiling mud pools or other thermal activity. Theo Schoon thought Waiotapu showed 'nature at its most beautiful, its purest. That is when nature shows itself as a designer . . .' He considered his photographic work as his sketchbook and notebook: 'These are the things I love, these are the things I admire, these are the things that bring me joy . . .'

Many of the best photographic observers of New Zealand life were born overseas. Having studied art in Amsterdam before arriving in New Zealand in 1939, Theo Schoon was also a well-known painter, carver of gourds and Balinese dancer. Maybe immigrant artists like Schoon could see New Zealand reality with fresh eyes. Perhaps the camera was one way of embracing and coming to terms with their new home?

- **Theo Schoon** (born in Indonesia, 1915, died 1985),
 Silicated sticks arranged in thermal settings, Waiotapu, c. 1966

Like Theo Schoon, Auckland photographer Jae Hoon Lee looks for patterns and designs in nature – as in this photograph of waves at the surf beach of Piha, on Auckland's West Coast. The difference is that Jae Hoon Lee uses all the devices of the digital/computer age: he manipulates and adjusts what we will see in the final image. In this photograph, the waves don't seem to know which way to go. Is this the turning of the tide, or is it just a digital effect?

• **Jae Hoon Lee** (born in Korea, 1973), *Piha*, 2006

Peter Peryer's images often seem to be telling us something about New Zealand – about who we are and what we value. He got himself into trouble some years back when he photographed a dead cow beside a motorway and used it as the cover image for a book of his photographs published in Germany. Some people wondered: what will the Germans think?

What attracted him to make a photograph of neenish tarts? These delicacies used to be piled up in the windows and display-cabinets of most New Zealand bakeries – nowadays you hardly ever see them. Peter Peryer's photographs take us back to those days. Without the appetising colours, Peter's black-and-white cakes become an abstract pattern

– like wheels in some strange machine. Here's a thought: when the neenish tarts are photographed in black and white, they are no longer edible. They've become something else.

A repetitious arrangement of ordinary things like Peter's tarts (or like Alan Knowles's biscuits on page 32) can yield unexpected and fascinating results. Another photographer interested in abstract patterns, John Johns worked for the New Zealand Forestry Service and spent years photographing geometrical plantations of trees from the air as well as from the ground. He also made images of vegetation, such as *Celmisia incana*, finding beauty in the patterns of nature, usually rendered in exquisitely detailed black and white.

- **Peter Peryer**, *Neenish Tarts*, 1983
- **John Johns** (born 1924, died 1999), *Leaves of Mountain Daisy (Celmisia incana)*, 1970s

Making history

Photographs bring events back to life. They are reminders of times when things have gone right or wrong; they speak to us of people who have been lost or survived.

One of photography's most important and influential usages is to record world and local events. Wars, sports, beauty pageants, political rallies, moments in human history . . . The best photographs of public events are often taken from an angle or viewpoint you would least expect. In Bruce Connew's photograph (on right) you can't even see the face of the central character. Bruce had made his way backstage during a muscle-building competition in Papua New Guinea. Has the strong man just been handed a cellphone, or a mirror? Is he about to go on stage or is he wiping sweat from his head at the conclusion of his presentation?

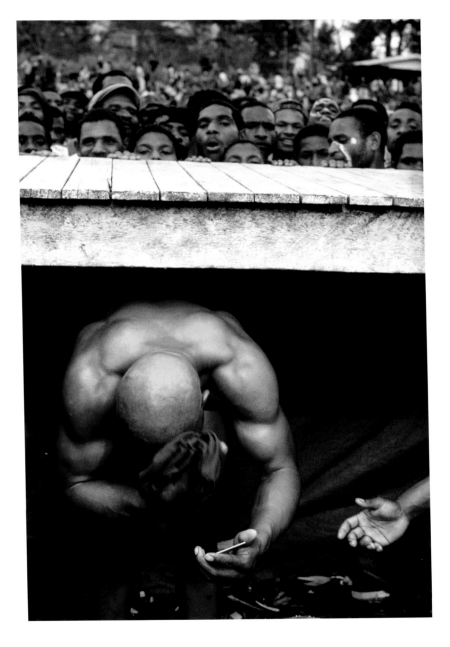

• **Bruce Connew,** *Muscleman*, Western Highlands, Papua New Guinea, September 2001

Gil Hanly took a series of photographs of the hull of the Greenpeace protest vessel *Rainbow Warrior*, shortly after it was sunk by French secret agents in Auckland harbour in mid-1985. The photograph on the left captures the brutality of the bombing (in dramatic contrast to the word PEACE visible in the photo). At the same time the image has a mythical quality. The figure in the raincoat is like Jonah being swallowed by a whale. He disappears into the blackness of the image – and it might be a tunnel or a tomb. It is as if he has gone off into the darkness that lies beyond the surface of the photographic paper upon which Gil Hanly has made this black-and-white print.

In another photograph of the sunken vessel, the silver-grey of the photograph echoes the steely, still, freezing waters of the midwinter Waitematā Harbour. Apart from a single figure near the centre of the composition, all the lines in the foreground are diagonal – as though the world has been knocked off balance. It is through documentary or history photographs that we remember events like the *Rainbow Warrior* bombing. Gil's photographic record also stands as a memorial to the man, Fernando Pereira – a photographer – who lost his life when the ship was sunk.

- **Gil Hanly** (born in Levin, 1934), Rainbow Warrior *in dry dock, Devonport*, August 1985, and Rainbow Warrio*r sabotaged at Marsden Wharf*, July 1985

Survivors

Forty years after the interisland ferry *Wahine* sank during an horrendous storm in Cook Strait, the photograph below appeared on the front page of the *Dominion* newspaper. While 52 people lost their lives when the ship went down in April 1968, this photograph – taken on the rocky coast along from Eastbourne – shows a truck laden with survivors, most of them children. They have just swum ashore through the treacherous surf. It is a photograph of complete and utter exhaustion. Helped along by two men in suits, the vehicle is bumping its way towards warmth and safety.

The day after this photograph appeared in the *Dominion* all those years after the disaster, the same newspaper published an interview with a middle-aged man who, although he had no memory of the photo, recognised himself in it. When he saw the photograph he was transported back to that terrible day. Those were his gangly legs – in sodden trousers – and those were his cold, pale feet dangling from the back of the Land Rover.

• **Photographer unknown,** *Wahine* survivors and their rescuers on Pencarrow Coast Road, 1968

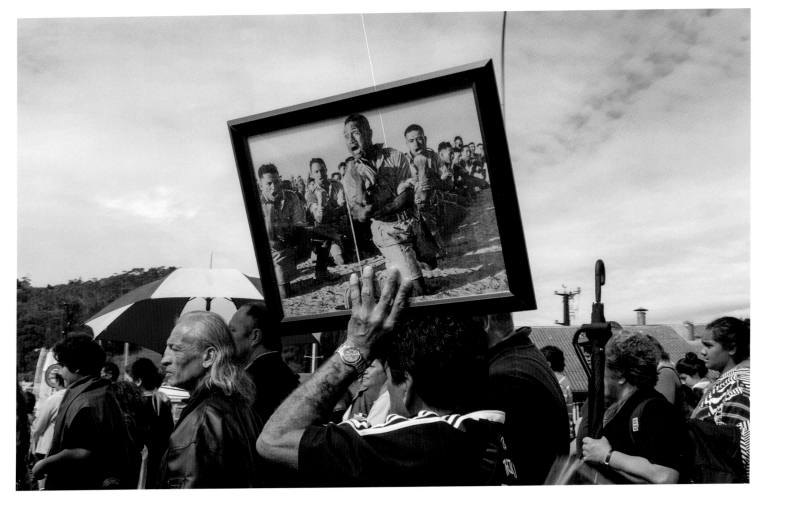

- **Natalie Robertson** (born in Kawerau, 1962, Ngāti Porou, Clan Donnachaidh), from a series documenting the Nga Tama Toa re-enactment, Gisborne, 25 October 2008. In 2008, Natalie Robertson photographed a re-enactment of the return of the Māori Battalion C Company to Gisborne after World War II. Along with 2000 descendants and whānau, Natalie traced the steps of the homecoming troops from the train station to a nearby marae, photographing as she walked.

On this occasion, photographs of casualties as well as survivors of the war were held above the heads of family members. These sacred, treasured photographs had been taken down from the walls of homes and meeting houses. In Natalie's photo, a framed picture is raised to the sky; the soldiers are remembered, honoured and their lives celebrated. (Tracing the old photo of the haka, via the Digital NZ website, I discovered that members of the Māori Battalion were, on this occasion, performing in Egypt for the King of Greece. No one knows who took the photograph, but the four men in the foreground are John Manuel, Maaka White, Te Kooti Reihana and Rangi Henderson.)

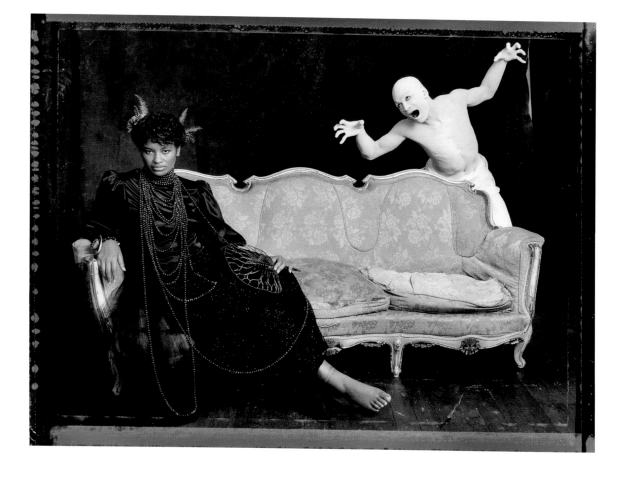

Predominantly black and white (or toned sepia-brown), the photographs of Andrew Ross (page 106), Laurence Aberhart (page 91) and Shigeyuki Kihara (above) often look like they could have been taken a hundred years ago. Their work could easily hang on the same wall as the photographs of Margaret Matilda White, R. P. Moore or the other pioneering photographers we encountered earlier.

Yet the photography of Shigeyuki Kihara, in particular, is also very much of our time. From a modern-day viewpoint, her images explore ideas of identity and colonial history, while indulging her vivid imagination and her fascination with both costumes and the physical body.

Maybe photographers who remain committed to the old ways of working are making a stand against the modern world with its billboards, digitisation and mass media? In their images, we return to a private, secret world, in which messages are whispered and meanings are only hinted at.

- **Shigeyuki Kihara** (born in Samoa, 1975), *Daughter of the High Chief*, 2003 (photograph by Duncan Cole)

Like Laurence Aberhart, Andrew Ross makes black-and-white 'contact' prints which are the same size as the negative from which they are printed (in this case, 10 by 12 inches, or 24 by 30 centimetres). This is photography in its purest form; the images are produced using technology that has hardly changed since the nineteenth century.

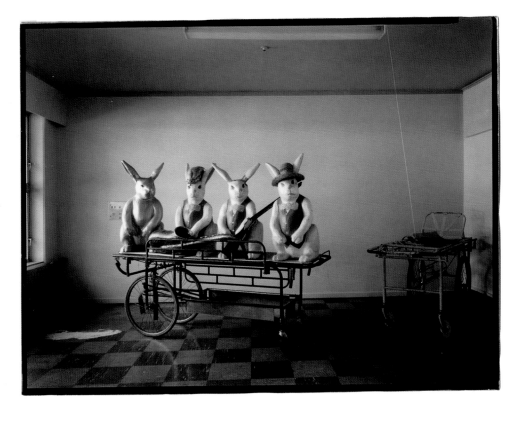

How is it that Andrew Ross, Shigeyuki Kihara and others capture such immensely subtle tones in their images? Photographic conservator Mark Strange says it boils down to the fact that all photographs – whether they are negatives, prints or slides – are made up of many layers.

For the technically minded, here is how it works, according to Mark: 'Photographic prints have a base layer which supports another layer – a binder layer – which holds the image particles in place, like suspending pieces of fruit in a jelly. The most common binders are highly purified gelatin, from animal skins and bones, or (in the nineteenth century) albumen, from egg whites. The image material in most black-and-white images is silver. The particles are so incredibly fine that they appear black – without colour or shine. The shape, size and position of these nanoparticles determine how they refract different wavelengths of light – determining our perception of their colour . . .

'Photographers sometimes use an extra processing step in which prints are treated in solutions containing gold, copper, iron, platinum or sulphur, to change the shape of the image particles in order to create different colours and tones.'

• **Andrew Ross**, *Fever Hospital, Mt Victoria, 23/8/2005*

A photograph that doesn't exist

A few years ago, my 11-year-old son Felix and I went out on a photo shoot with Laurence Aberhart. We drove to an old Sea Cadets hall – TS AMOKURA – at Greta Point, Wellington. Felix was a junior cadet so he knew the building well. And he thought the interior looked a lot like a Laurence Aberhart photograph. It was Felix's idea to get Laurence down there to take a picture.

To begin with, it took Laurence ages to set up his nineteenth-century view-camera on its spindly wooden legs (see the photograph on right). He took out a light meter, to work out the amount of light in the room (not much) and he calculated that the camera lens would need to be left open for maybe eight or ten minutes to get a good result. When all the preparation was done, Laurence opened the shutter and the light in the room started doing its business with the chemicals on the photographic negative inside the camera.

Laurence then told Felix that, if he felt like it, he could run around in front of the camera – so long as he kept moving he would not come out in the photograph. Felix obliged, skipping and jumping around in front of the camera. Sure enough, when Laurence developed the negative, Felix was nowhere to be seen – he hadn't stayed in one place long enough for the photographic process to register his being there.

There was, however, a slight problem with the exposure. The edges of the photograph were, Laurence later told me, blurred – as if the camera had moved while the lens was open. Maybe this was on account of Felix bumping the floor. Old cameras are sensitive, unforgiving pieces of equipment.

However, when old equipment, like Laurence's camera, works well, the result can be the most beautiful, subtle, haunting images imaginable: photographs that take you, the viewer, somewhere that a modern, digital print can't.

Laurence makes a point of photographing old buildings and monuments which he suspects won't be standing much longer (like the dairy factory on page 91). Three weeks after he photographed the hall at Greta Point, the building was demolished. Alas, because of a little movement of the floorboards, a photograph from the negative will never be printed. The image, as well as the building, is lost. All that remains is a memory and this little story . . .

• Peter Peryer, *Laurence Aberhart,* 2010

Look both ways

Cameras look both ways: when you take a photo, the camera isn't only looking away from you, it is looking very closely at you too. As we have seen, a photo says as much about the person behind the camera as it does about the world out front.

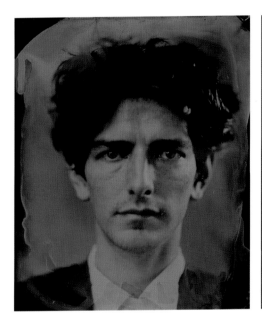

• Ben Cauchi, *Self portrait*, 2006, and *The Doppler Effect #5*, 2010

In the course of this book, we have seen a few of the things that photography can be, as well as what it can do – whether you are using a nineteenth-century view-camera or a twentieth-century Leica (with its roll of celluloid film inside) or the latest twenty-first-century digital camera. Whether you are working in a studio or snapping pictures from the window of a speeding car, there are new places photography can take you; new ways of seeing it can teach you.

Some photos are of passing interest, some appeal instantly, while others ask you to return to them. Over time, some photographs attain iconic status – they become part of a nation's way of thinking about itself.

Marti Friedlander's photo of the kuia and great-granddaughter on page 58, Leslie Adkin's high-altitude workers (page 23) and Robin Morrison's pink caravan (page 86) are among the iconic images included in this book. Not only have these images reflected the kind of people we are, they have helped to shape our way of thinking about ourselves and our future.

As well as being something you look at for pleasure or to discover things, photography might be something you want to explore further, on your own terms. One of the best ways of learning how to take a photograph is to look long and hard at images that you like. Think about how the images in this book are composed. Where is the light coming from?

Is it natural or artificial? Is it coming from the front or back or side? Think about all the decisions that the photographer made – their choice of subject, where they were standing, what type of camera they were using. The basis for taking good photos is, first, being able to look closely at photos, to absorb them, and learn from them.

When we look at a photograph, we all see different things. Did you see what I saw? That is a question we often ask. Or maybe you saw something completely different? That's good too. Art is like that. Different people see differently, even when they are looking at the same thing. Often, when you take a second look at a photograph, you will find its meaning has changed. Photography is a living art form – it doesn't finish when the picture is taken or the print made. These images are alive. See what you can see, and then look again, and again.

- **Glenn Jowitt** (born 1955, died 2014), *Lincoln St, Ponsonby*, 1981

A strange box roams the earth. It asks, What sort of a day are you having? And then it remembers your answer long after you are gone.

- **Ans Westra,** *Opening of meeting house 'Arohanui Ki Te Tangata', Waiwhetu Marae,* September 1960

Things to read now: *Pictures They Want To Make: Recent Auckland Photography,* Chris Corson-Scott & Edward Hanfling (Photoforum, 2013); *Into the Light: A History of New Zealand Photography,* David Eggleton (Craig Potton, 2006); *Imposing Narratives: Beyond the Documentary in Recent New Zealand Photography* (Wellington City Art Gallery, 1989); *Contemporary New Zealand Photographers,* edited by Hannah Holm & Lara Strongman (Mountain View Press, 2007); *Bold Centuries,* Haruhiko Sameshima *et al.* (Rim Books, 2009); *New Zealand Photography from the 1840s to the Present: Nga Whakaahua o Aotearoa mai i 1840 ki naianei,* William Main & John B. Turner (Photoforum, 1993); *PhotoForum at 40,* Nina Seja *et al.* (Rim Books, 2014); *New Zealand: A Century of Images,* Paul Thompson (Te Papa Press, 1998); and *Views / Exposures: 10 Contemporary New Zealand Photographers* (National Art Gallery, 1992).
Things to do online: Numerous works by individual artists can be found on the internet, at such sites as McNamara Gallery Photography, www.mcnamara.co.nz; Photospace Gallery, Wellington, http://photospacenz.weebly.com; and PhotoForum, www.photoforum-nz.org. A vast range of photographic images can be found on www.digitalnz.org (this site is particularly good for historical images and links to major public museum and gallery databases). The websites of Auckland Art Gallery Toi o Tāmaki (which includes works in the Chartwell Collection), the Museum of New Zealand Te Papa Tongarewa, Christchurch Art Gallery and Dunedin Public Art Gallery are all useful sources with good images. And a list of publications about individual photographers in this book, further activities, and links to recommended websites and online resources can be found on the See What I Can See page on the Chartwell Trust website: www.chartwell.org.nz/About/ChartwellPatronage/SeeWhatICanSee.aspx

Credits: The photographs in this book are reproduced with grateful thanks to, and courtesy of, the photographers themselves; the estates of Helena Hughes, Frank Hofmann, John Daley, John Pascoe, Robin Morrison, Christopher Perkins, Eric Lee-Johnson, Theo Schoon and John Johns; the Len Lye Foundation and the Glenn Jowitt Trust; and Fairfax NZ, Ngā Taonga Sound & Vision, the British Postal Museum and Archive, the McNamara Gallery, the Sonnabend Gallery, Photospace Gallery, Two Rooms Gallery, the Sarjeant Gallery and the galleries and institutions listed below. **Alexander Turnbull Library:** page 1, Jacques, *Ian Crane, dressed up as a tube of Colgate toothpaste,* PA12-2551-6; page 2, Pascoe, *Maori school children from Tokomaru Bay, visiting the elephant at Wellington Zoo in Newtown,* 1/4-000834-F, John Pascoe Collection; pages 18–19, Moore, *Gannetts, Cape Kidnappers, N.Z.,* PA6-287, R. P. Moore Collection; page 18, Carnell, *Portrait of Susan Jury (Huhana Apiata),* G-22142, S. Carnell Collection; page 19, Pascoe, *A female linen flax worker driving a tractor in Geraldine,* 1/4-000957-F, John Pascoe Collection; page 20, Pollard, *Participants in Nelson celebration of Queen Victoria's Diamond Jubilee,* G-283-10X8, Tyree Collection; page 21, photographer unknown, *The camp, the cook and the cabbage, Wairarapa,* F-22483-1/2; page 26, Kent, *A dog poking its head out of a kennel,* F-10144-1/2, Thelma Kent Collection; page 47, Harding, *Mrs Morgan and child,* 1/4-008511-G; and page 52, Pascoe, *Sara and Anna Pascoe dressed up as the rabbit and Alice, from 'Alice in Wonderland',* 1/4-068214-F, John Pascoe Collection. **Auckland War Memorial Museum Tāmaki Paenga Hira:** page 22, White, *Three nurses riding bicycles, Auckland Private Hospital* and *Three nurses on bicycles falling over,*

• Haruhiko Sameshima, *Photo vending machine, Hells Gate Geothermal Park*, Rotorua, 2006

Auckland Private Hospital, PH-NEG-B3542 and PH-NEG-B3540; page 24, White, *Margaret White dressed as Maori*, PH-NEG-B3598; and page 86, Morrison, *Pink Caravan, Harwood, Otago Peninsula*, PH-NEG-RMS-vsFTR79-135, and *Ben and Balthazar, Fox River, West Coast*, PH-NEG-RMS-sFTR46-336. **Te Papa Tongarewa Museum of New Zealand:** page 23, Adkin, *Mangahao – Wellington city transmission line*, B.023165, gift of G. L. Adkin family estate, 1964; page 66, Hofmann, *Portrait of a pianist (Lili Kraus)*, O.003592; page 71, Lee-Johnson, *Self Portrait in Infra Red, Waimamaku, Northland*, O.006102; page 90, Brake, *Mount Egmont/Taranaki from Tariki*, CT.031532, gift of Mr Raymond Wai-Man Lau, 2001; and page 98, Schoon, *Silicated sticks arranged in thermal settings*, CA000812/001/0001/0009, purchased 2001 with New Zealand Lottery Grants Board funds. **Auckland Art Gallery Toi o Tāmaki:** page 40, Pardington, *Taniwha*, selenium-toned gelatin silver print, Chartwell Collection, 1998; page 43, Peryer, *Still Life*, purchased 1982; page 50, Lee-Johnson, *Opo, the Hokianga Dolphin (#16)*, gelatin silver print, gift of Elizabeth Lee-Johnson in memory of Eric Lee-Johnson, 1994; page 90, Perkins, *Taranaki*, oil on canvas, purchased 1968; page 105, Kihara with Cole, *Daughter of the High Chief*, gelatin silver print, purchased 2012. **Nelson Provincial Museum:** page 45, Tyree brothers, *Love Wedding*, 179468, Tyree Studio Collection. **Govett-Brewster Art Gallery:** page 49, Lye, *Child with Figurine*, Len Lye Foundation Collection; page 91, Aberhart, *Taranaki from Awatuna, Taranaki, 27 September 2009*; page 107, Peryer, *Laurence Aberhart*. **Auckland Libraries:** page 81, Firth, *Photograph of the interior of Clifton Firth's studio*, 34-S517C, Sir George Grey Special Collections.

A last word on the photos: The photograph on the very first page of the book is by J. A. Jacques, *Ian Crane, dressed up as a tube of Colgate toothpaste,* c. 1953. On page 2 is John Pascoe, *Maori school children from Tokomaru Bay, visiting the elephant at Wellington Zoo in Newtown, 10 December 1943,* and following that, on page 4, is a photo by Helena Hughes, *Zia in mask,* 2007. The photos on the cover are by Victoria Birkinshaw and Ans Westra (see if you can also find them inside the book). And all of the photographs on the endpapers are by Bruce Foster, with some annotations, drawings and idle thoughts by me. Acknowledgements: I have been lucky, over the years, to spend time with some great photographers. More than anything else, what I have learned from them is a state of attentiveness, of looking closely and working intuitively – these are useful skills for writers, artists and people in just about any walk of life. My deepest thanks to all the photo-artists in this book. I'm especially grateful to Deborah Smith, with whom I have had a good many conversations over the past decade. She, Mark Smith and Bruce Foster generously took photographs especially for this book (and Bruce pillaged his photographic archive for the endpaper images). Huge thanks also to Helena Hughes, Peter Black and Mary Macpherson, Lucien Rizos; Laurence Aberhart, Gil Hanly, Marti Friedlander, Alan Knowles, Robert Cross and, from further afield, Mari Mahr. Among the young and curious who energetically helped with this book are Josephina O'Brien, Holly and Ruby Dixon (it was Holly's idea that Lorde should make an appearance); Carlo Bornholdt and Greta Wilkins; and Paul, Luke and Ivy Austin. Thanks also to Abby Cunnane, Emma Bugden, Lara Strongman, Heather Galbraith, Mark Strange, James Gilberd, Paul McNamara, David Eggleton, Courtney Johnston, Kate de Goldi, Geoff Dyer, Ron Brownson, Andrew Johnston and Jenny Bornholdt. Thanks to Anna Hodge, Katrina Duncan, Margaret Samuels, Louisa Kasza and Sam Elworthy at Auckland University Press, to Sarah Maxey for her cover design and to Mike Fudakowski for his proofreading. As the recipient of the 2015 Stout Memorial Fellowship, I am grateful to director Lydia Wevers and the Stout Research Centre, Victoria University of Wellington. I also acknowledge the Arts Foundation of New Zealand, whose support during the early stages of this project was timely and vital; and give a huge thank you to Rob and Sue Gardiner for the Chartwell Trust's support of the book and for hosting a webpage for it. Finally, a special thank you to Marion, Vicki and all the Hughes whānau of Longlands, Hawke's Bay, and places beyond; and to Phil, Rudi and Zia.

First published 2015

Auckland University Press
University of Auckland, Private Bag 92019
Auckland, New Zealand
www.press.auckland.ac.nz

Text © Gregory O'Brien, 2015. Images © the photographers.

ISBN 978 1 86940 843 5

Publication is kindly assisted by

A catalogue record for this book is available from the National Library of New Zealand

Book design by Katrina Duncan
Cover design by Sarah Maxey

Printed in China by 1010 Printing International Ltd

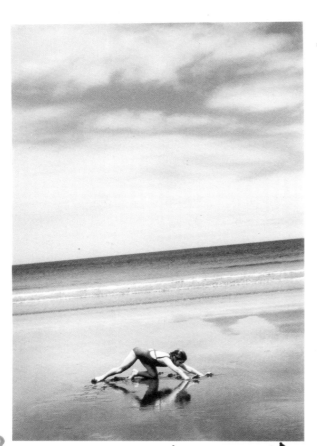

ZOOM

shot list 27 +29 33

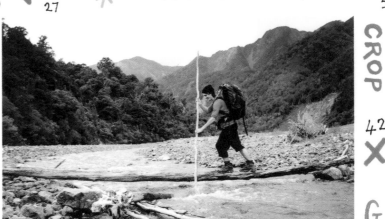

CROP 42 X G

INFINITY STOP

focal length

f11

TONE RANGE POINT OF VIEW BRIGHTNESS

XIV

PROOF SHEET

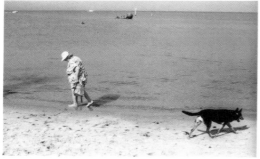

EACH DAY IS A CAMERA
THE SHUTTER OPENS
(DAWN) AND CLOSES
(DUSK)

1/250th sec.

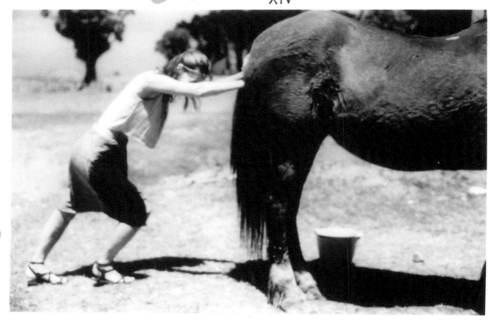